THE CLARK

THE INSTITUTE AND ITS COLLECTIONS

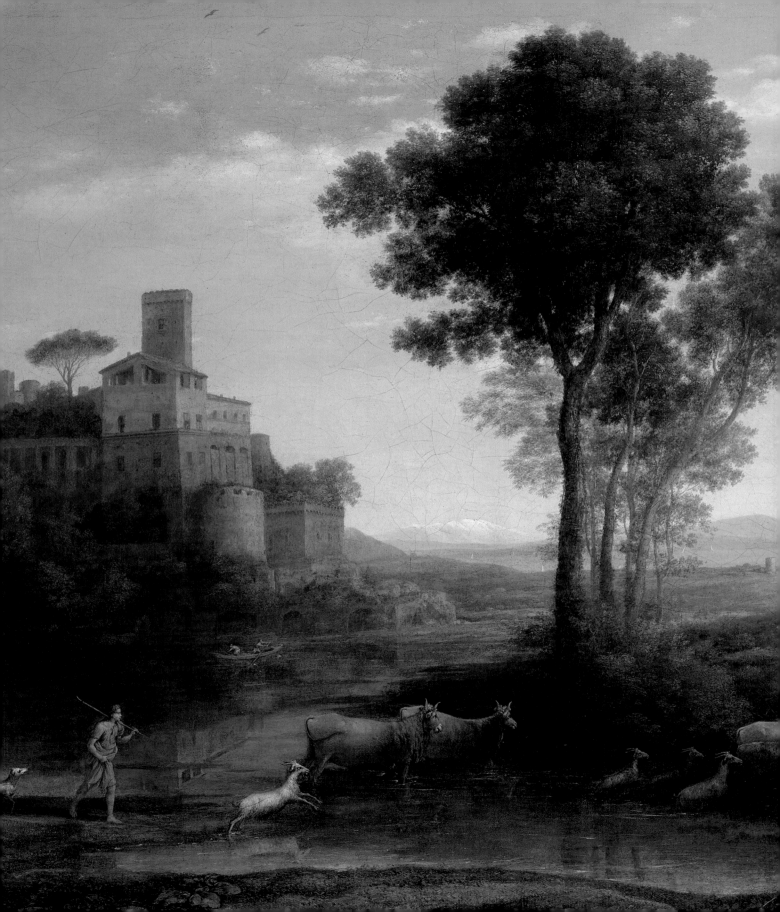

THE CLARK

THE INSTITUTE AND ITS COLLECTIONS

Clark Art Institute
in association with
Scala Arts Publishers, Inc.

Text and photography ©2014 Sterling and Francine Clark
Art Institute

Book ©2014 Scala Arts Publishers, Inc., and the Sterling and
Francine Clark Art Institute

Produced by the Clark Art Institute
225 South Street
Williamstown, Massachusetts 01267
www.clarkart.edu

Essays by Michael Conforti, *Director*
Catalogue entries by Michael Cassin, *Director, Center for
Education in the Visual Arts*

Thomas J. Loughman, *Associate Director of Program
and Planning*
Anne Roecklein, *Managing Editor*
Michael Agee, *Photographer*
Dan Cohen, *Special Projects Editor*
Hannah Rose Van Wely, *Publications Assistant*
Kjell Wangensteen and Antongiulio Sorgini,
Research Assistants

Copyedited by Mariah Keller
Proofread by Zoe Charteris
Printed and bound in Malaysia by CS Graphics
10 9 8 7 6 5 4 3 2 1

First published in 2014 by Scala Arts Publishers, Inc.
141 Wooster Street
Suite 4D
New York, NY 10012
www.scalapublishers.com
Scala − New York − London

Distributed outside the Clark Art Institute by
Antique Collectors' Club Distribution
6 West 18th Street
4th Floor
New York, NY 10011

Front cover: John Singer Sargent, *Fumée d'Ambre Gris (Smoke of
Ambergris)*, 1880 (cat. 49)

Title page: Claude Lorrain, *Landscape with the Voyage of Jacob*,
1677 (cat. 2)

Divider page details:
pp. 18–19: John Constable, *The Wheat Field*, 1816 (cat. 8)
pp. 56–57: Berthe Morisot, *The Bath*, 1885–86 (cat. 42)
pp. 96–97: Albrecht Dürer, *Sketches of Animals and Landscapes*,
1521 (cat. 50)
pp. 136–37: Sir Lawrence Alma-Tadema; Sir Edward John
Poynter; Johnstone, Norman, & Company, London; and
Steinway & Sons, New York, *Model D Pianoforte and Stools*,
1884–87 (cat. 96)

ISBN: 978-1-85759-890-2

Library of Congress Cataloging-in-Publication Data

Sterling and Francine Clark Art Institute.
 The Clark : The Institute and Its Collections.
 pages cm
 "Essays by Michael Conforti, Director; Catalogue entries by
Michael Cassin, Director, Center for Education in the Visual
Arts."
 Includes index.
 ISBN 978-1-935998-19-8 (sterling and francine clark art
institute, co-publisher)—ISBN 978-1-85759-890-2 (scala arts
publishers, inc., co-publisher) 1. Sterling and Francine Clark
Art Institute—History. 2. Art—Massachusetts—Williamstown.
I. Conforti, Michael. II. Cassin, Michael. III. Title.

N867.A835 2014
708.144'1—dc23

 2014003986

Contents

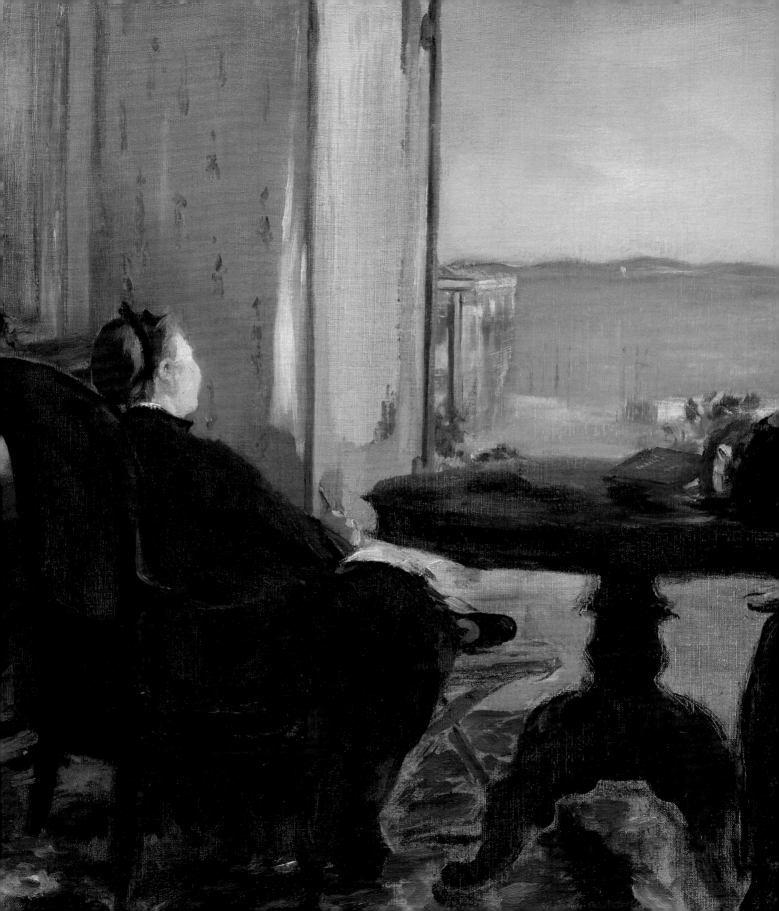

Foreword

In 1910 Robert Sterling Clark ordered numerous renovations to the house
he had purchased that year in Paris. Among the things he specified was the
creation of a salon devoted to the display of art. Clark called the room his
"galleria" and it was there that he showcased the works that he and his future
wife, Francine, began acquiring in the 1910s.

The collection can now be found in a vastly different setting. This book
traces the incredible journey of the collection from the Clarks' "galleria" to
the Clark Art Institute—an art museum and center for research and higher
education in the visual arts located on 140 acres in the Berkshires of western
Massachusetts. Today the Clark is recognized throughout the world as one of
the few institutions committed both to the aesthetic appreciation of works
of art and to the intellectual values that form our understanding of the
visual arts.

In four sections, Michael Cassin, director of the Center for Education in the
Visual Arts (CEVA), explores some of the Clark's most important and beloved
American and European paintings, works on paper, sculpture, and decorative
arts. He shares the extraordinary insight he has gained through acquainting
visitors of all ages with the Clark's collection via an array of educational
programs. In introductory sections that detail the history and current program
of the Institute, I provide the story of the Clark from its origins as a private
collection to the institution it is today. The essays detail not only the Clark's
museum programs for visitors and the community but also the Institute's
robust Research and Academic Program, which offers fellowships for inter-
national scholars as well as lectures, symposia, colloquia, and conferences on
the Clark campus and at sites around the world. The Clark's research program,
extensive art library, and a graduate program organized in collaboration with

Previous page,
Édouard Manet (French,
1832–1883), *Interior at
Arcachon*, 1871. Oil on
canvas, 15⁷/₁₆ × 21¹/₄ in.
(39.2 × 54 cm). Sterling
and Francine Clark
Institute, Williamstown,
Massachusetts (1955.552)

Left, View of Schow Pond
with the Clark's original
white marble Museum
Building visible through
the trees

Williams College underscore its deep commitment to fostering scholarship and education through the understanding and interpretation of visual culture.

As readers of this book will discover, the Clark is a place at which great works of art and important ideas converge. The expansion of the campus, which was completed in July 2014, includes new galleries and facilities for museum visitors and scholars alike, ensuring that the Clark remains a special institution for years to come. The experience of the Clark is a distinct and enriching one for the many visitors, scholars, and students who come in contact with it every year. The Institute, as well as its tranquil New England setting, is loved by everyone, whether they experience it for a couple of hours or for many years.

Michael Conforti, Director
Clark Art Institute

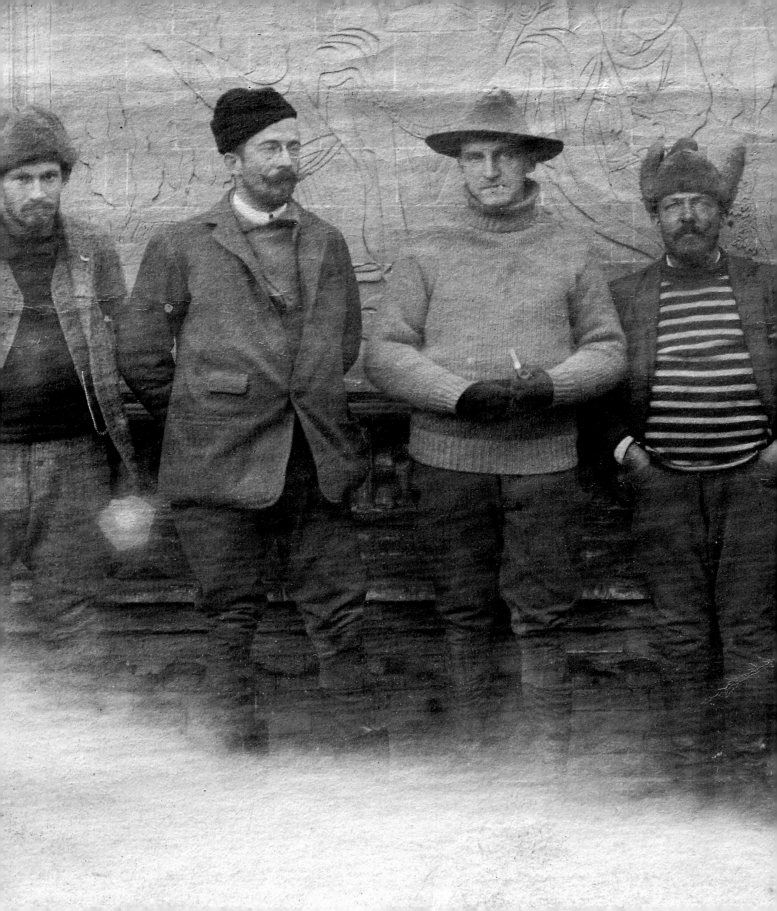

ROBERT STERLING CLARK
A MAVERICK
SOLDIER, EXPLORER, HORSE BREEDER, AND ART COLLECTOR

On the morning of May 16, 1908, a young Robert Sterling Clark, with a thirty-eight-member expedition team on forty-four mules, embarked on a scientific journey through a remote and little-known region of northern Ch[ina] (fig. 1). It would be a challenging adventure far removed from the luxuries and conveniences to which Clark was accustomed. From a young age he ha[d] displayed an independent streak that was unusual for the son of a wealthy prominent New York family. After graduating from Yale in 1899 at the age [of] twenty-two, he was inspired by adventurers of the day like Theodore Roose[velt] to volunteer for the US Army (fig. 2). The following year he was sent to Chi[na] as part of an international force attempting to settle the Boxer Rebellion (1899–1901). Clark served with distinction in China, and then the Philippin[es,] resigning after five years of service; however, he soon rekindled his appetit[e] for foreign adventure. Returning to China, and aided by the English natura[list] Arthur de Carle Sowerby, he mounted an expedition to the remote interior [of] the Shanxi, Shaanxi, and Gansu provinces. The account of the expedition w[as] published in *Through Shên-Kan* (1912), which included detailed charts and m[aps] documenting the fauna, flora, geological formations, and climatic conditio[ns] that the expedition team encountered as well as photographs and watercol[ors] of the landscape, native population, temples, and archeological sites along the way. Clark fondly recalled the experience throughout his life, and he ev[en] financially supported members of the expedition team for decades to come.

Born in New York in 1877, Sterling Clark was the second of four childre[n] (fig. 3) of Alfred Corning and Elizabeth Scriven Clark. Edward Clark, Alfred['s] father, became an attorney shortly after his graduation from Williams Col[lege] in 1831, and he later partnered with the actor and sometime inventor Isaac Singer, whose idea for an improved sewing machine became, through Edw[ard]

Fig. 1
Previous page, Members of the Clark expedition team at Yulin, Shaanxi province, December 1908 (*left to right:* Arthur de Carle Sowerby, Robert Sterling Clark, Nathaniel Haviland Cobb, George A. Grant, Henry Edward Manning Douglas)

Fig. 2
Robert Sterling Clark in his army uniform, c. 1899

intercession and marketing acumen, a practical household necessity
nd the world. Upon his death in 1882, Edward left an estate valued at
million that included extensive real estate on the West Side of Manhattan
he had bought and developed toward the end of his life. To his grand-
ren he bequeathed land in Cooperstown, New York, and four individual
blocks in Manhattan (fig. 4), one of which includes the famous Dakota
ment building, which Edward had commissioned in 1880 (it remained a
family property until the 1960s). Though the Clarks lived in New York
they had strong ties to Cooperstown, where Edward's wife, Caroline, had
born and raised. Sterling and his three brothers spent their summers at
eigh (fig. 5), a house that their grandfather had built and adorned with
s of art purchased on the family's first trips to Europe in the 1860s and
Alfred had supported artists throughout his life, and he and his wife
d works to the collection that his father had assembled. An interest in art

Fig. 3
Left to right, Ambrose, Sterling, and Stephen Clark at the family's farm in Cooperstown, c. 1887

collecting would rub off on Sterling and his brother Stephen, though Sterling's interest only became apparent following his military service and his expeditionary adventures in the Far East.

When compared with other great American collectors of the early twentieth century, Sterling was decidedly different. He was wealthy, yes, but his passions in life represented an unusual combination of interests, commitments, and expertise. A battle-tested soldier, he harbored quiet but serious intellectual pursuits and was a lover of good food and fine wine—in fact, he was a very good cook. Independent in all his pursuits, he was a successful, "contrarian" financial investor and a clever breeder of thoroughbred horses. He would never serve on any board, profit or not-for-profit, and he showed no signs of corporate engagement of any kind. Though committed to works of art, he was also as guarded about his art collection as he was about his personal and financial life. He lived abroad for decades, spoke only French to his wife, and in some ways imitated a French gentleman's lifestyle—an elegant boulevardier who resided in refined domestic environments that functioned as both home and retreat from the world. Most important, Clark's experience of war was unlike that of many American collectors of his day. Not only had he served in China and the Philippines at the turn of the century and in Europe during World

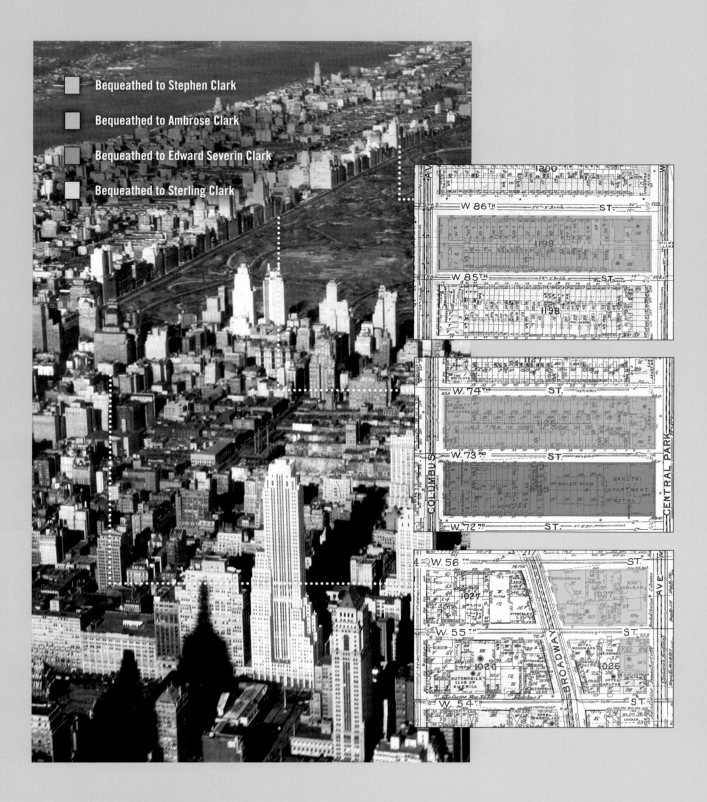

Bequeathed to Stephen Clark

Bequeathed to Ambrose Clark

Bequeathed to Edward Severin Clark

Bequeathed to Sterling Clark

Fig. 4
Left, Areas of the Upper West Side of Manhattan that Edward Clark bequeathed to his four grandsons in 1882. Photo by Underwood Archives/Getty Images

Fig. 5
Fernleigh, the Clark family home in Cooperstown, New York, c. 1890

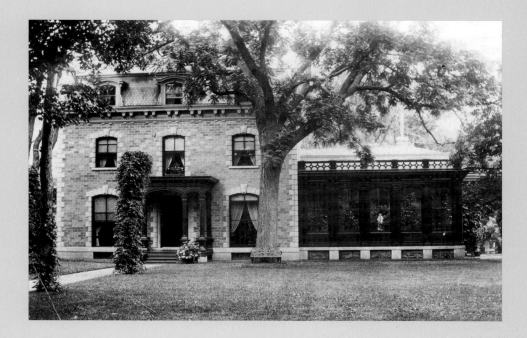

War I, he also had experienced the buildup and outbreak of World War II firsthand. In 1938 Clark emptied his Paris house of his art collection in anticipation of the impending destruction and, upon visiting the city one year later, he found himself in an air-raid shelter as bomb sirens sounded in the French capital. Those events, as well as the 1944 Allied bombing of his Normandy horse farm, made him keenly aware of the ways in which war can affect one's personal and material life.

Clark moved to Paris in 1910 shortly after completing his expedition in China. He intended to mount another eight-month sojourn to Egypt; however, those plans were shelved as he grew fond of the city and the life he found in France. Within a year of his arrival, he purchased a Second Empire–style *hôtel particulier* in the sixteenth arrondissement and immediately arranged to have it reconstructed in the fashionable Louis XVI–style, with the assistance of the well-known English firm Waring and Gillow as well as the Parisian team Schültz and Leclerc. With a large salon on the first floor that featured fourteen-foot ceilings and cloth-covered walls (fig. 6), the house was well suited to display an art collection. Clark's days soon came to include morning rides in the Bois de Boulogne and, increasingly, visits to galleries and bookshops. He also took private language lessons in Spanish and Arabic. Clark's love of

Fig. 6
Galleria of Sterling Clark's
house at 4 rue Cimarosa,
Paris, c. 1913

Paris was nurtured, too, by a chance meeting with the actress Francine Clary (fig. 7) at a poetry reading in March or November 1910, shortly after he arrived there. Born Francine Juliette Modzelewska, she was a year older than Clark, was an established actress in the Comédie-Française, and had a nine-year-old daughter. While not much is known of their courtship, Clark may have been the reason for Francine's early retirement from the stage. Their bond quickly became a close one, and throughout their long life together Francine would exert a subtle but significant influence on Clark in all things, including their art collection.

Clark's first steps as a collector are chronicled in his interactions with his younger brother, Stephen, who lived in New York and was beginning his career as chairman of the board of directors at Singer. The two often exchanged ideas on decorating and collecting, with Sterling regularly taking pleasure in offering advice to his younger brother from his Paris perch, including comments on furniture makers and decorators, as Stephen was in the process of building his own townhouse in New York. "I have learned a hell of a lot about decorating," he wrote to Stephen in October 1911, "and I have spent a lot of time learning it." They spoke about works of art as well. Earlier that summer Sterling had

Fig. 7
Left, Francine (Modzelewska)
Clary, c. 1900; *right*,
performing in *Paraître* as
Mme Naizerone (*fourth from
the right*) at the Comédie-
Française, Paris, 1906

requested that Stephen send a group of paintings that had belonged to
their parents—including those by Jean-François Millet, Gilbert Stuart, and
George Inness—to hang in his new Paris home. The request sparked a disagree-
ment between the brothers, as Stephen—who had been given the charge of
disbursing the works from their parents' estate—reasoned that Sterling would
have little interest in paintings, given his older brother's army and explorer
commitments. Though quickly and amicably resolved, the dispute presaged
future altercations between the two brothers that would eventually set them
apart for decades.

Clark's early taste for paintings was catholic, even idiosyncratic. From
1912 to 1920, when he was acquiring many of his finest Old Master paintings
and drawings, he added important American paintings to his collection as
he started his now famous holdings of Impressionist works. A landscape by
Meindert Hobbema (purchased in 1912) began a long and fruitful relationship
between Clark, P. and D. Colnaghi and Obach, and Colnaghi's American part-
ner, M. Knoedler and Co. One of Clark's greatest collecting triumphs in those
years was the purchase of Piero della Francesca's *Madonna and Child Enthroned
with Four Angels* (see cat. 27) in 1914 from Colnaghi. The work became the center
of his early group of Italian Renaissance paintings—in 1914 alone he bought

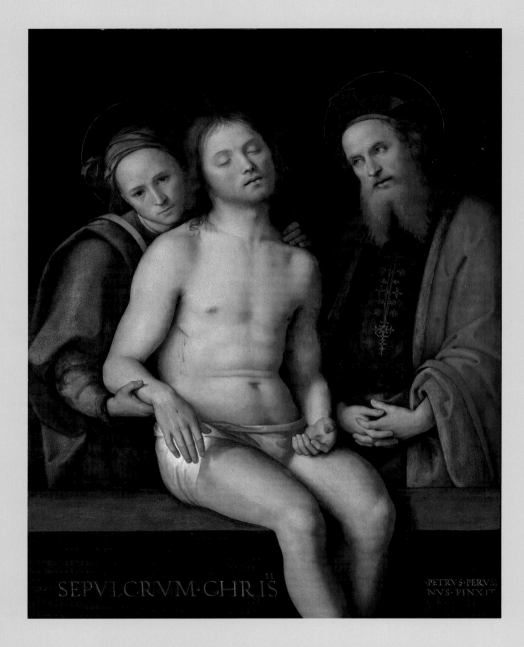

Fig. 8
Perugino (Pietro di Cristoforo Vannucci) (Italian, c. 1450–1523), *Dead Christ with Joseph of Arimathea and Nicodemus (Sepulcrum Christi)*, c. 1494–98. Oil possibly with tempera on panel, transferred to fabric on panel, 36⁷/₁₆ × 28¼ in. (92.6 × 71.8 cm). Sterling and Francine Clark Art Institute, Williamstown, Massachusetts (1955.947)

works by Luca Signorelli, Perugino (fig. 8), and Bartolomeo Montagna, as well as panels attributed to Antonello da Messina and Benozzo Gozzoli. Clark also acquired American paintings, beginning with *A Venetian Interior* (fig. 9) by John Singer Sargent in 1913 and, soon after, Sargent's masterpiece *Fumée d'Ambre Gris* (see cat. 49). Those purchases were followed in 1915 by one of

Fig. 9
John Singer Sargent (American, 1856–1925), *A Venetian Interior*, c. 1880–82. Oil on canvas, 19 1/16 × 23 15/16 in. (48.4 × 60.8 cm). Sterling and Francine Clark Art Institute, Williamstown, Massachusetts (1955.580)

Winslow Homer's greatest Adirondack subjects, *Two Guides* (see cat. 15). All those paintings were sent to his house on the rue Cimarosa, off the Avenue Kleber, where they were hung in his Louis XVI–style rooms. With the purchase of Renoir's *Woman Crocheting* (fig. 10) in 1916, Sterling and Francine began their French Impressionist collection, which over the course of their collecting career would center on an important group of thirty-eight Renoirs.

Clark's early, notable acquisitions were realized with the help of dealers, but without advice from any "experts" in a traditional sense. An unpleasant experience with an art advisor, his father's sculptor protégé, George Grey Barnard, had soured Clark on the recommendations of all but the few dealers he came to know and trust. "Except for Knoedler and Colnaghi," he wrote to Stephen in August 1913, "you have got to know the game yourself and that is what I am trying to learn." Over his years of collecting, Sterling also went to great lengths to maintain his anonymity. He almost never lent works to exhibitions—and then, only anonymously—and unlike Stephen, he joined no museum boards and attended few openings or public social events. His circle

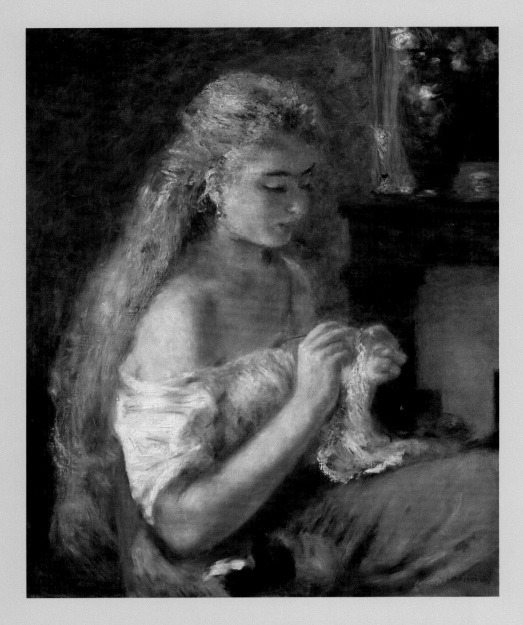

Fig. 10
Pierre-Auguste Renoir
(French, 1841–1919),
Woman Crocheting, c. 1875.
Oil on canvas 28$^{15}/_{16}$ ×
23$^{3}/_{4}$ in. (73.6 × 60.3 cm).
Sterling and Francine Clark
Art Institute, Williamstown,
Massachusetts (1955.603)

of friends in Paris was a small one, and he seems to have gone to great lengths
to maintain a private life. His dealer friends even took to referring to their
publicity-shy client as "Mr. Anonymous."

In 1920, after his recent marriage to Francine and the end of World War I,
Clark bought a spacious apartment at 300 Park Avenue, presently the site
of the Waldorf-Astoria Hotel. He intended to spend more time in the United

States. With his collection soon to be divided between New York and Paris, the New York branch of Knoedler became one of his favorite haunts. Clark's numerous letters and personal diaries provide a unique glimpse into the art market at that time. They are full of detailed information on works he considered purchasing, along with their prices as well as notes on quality and the activities of other collectors. Clark developed not only a strong discerning eye but also sharp opinions about art, a characteristic typical of passionate collectors with personal tastes that fuel the pursuit of specific works:

> *I don't give a damn about painters' dreams. What I want is paint. For instance, I don't care what Cézanne, Matisse and Gauguin thought or what they wanted to express. I could not give tuppence for all the pictures they ever painted or hoped to paint. The rules of painting cannot be broken. Renoir would have painted just as well in Titian's time. He, Degas, Manet at his best, Corot etc. are brothers of Titian, Van Dyck, Rubens. The others are just bad painters.*

The year 1923 marked a significant moment in Clark's life. His collection expanded with the purchase of Rembrandt's *Man Reading* as well as three Winslow Homers, two of which he installed in his New York apartment; the third was dispatched to Paris. One morning in June, Sterling's dissatisfaction with his brother's handling of the Clark family's trusts resulted in a fistfight between the two brothers in the Clark business offices. The disagreement centered on Sterling's desire to break certain trusts to allow his stepdaughter to inherit. Stephen was unwilling to do so. The rancor from the dispute resulted in an unsuccessful lawsuit brought by Sterling, and the lingering feud between the brothers lasted the rest of their lives. Given the commitment of each brother to the formation of their art collections, it is not surprising that the conflict would extend beyond financial matters to aesthetic ones. In 1927 Sterling recorded his disdain for Stephen's taste for works by André Derain and Henri Matisse. "Awful things…mere daubs of grotesque figures," he wrote. "It seems Stephen loves them and has several." Stephen was equally passionate about works of art, and he acquired what would become a very important collection of Post-Impressionist, early modern, and American paintings that he eventually donated to a number of institutions.

Sterling's investments outside of the contended family trusts, buoyed by his considerable financial acumen, allowed him to weather the stock market crash of 1929 and the early years of the Great Depression. He continued collecting art, buying freely while others were forced to sell. Among the works he purchased during that time was J. M. W. Turner's *Rockets and Blue Lights* (see cat. 4), which he bought in 1932 for half the price the original owner had paid. He also began to focus on breeding thoroughbred horses, and his accomplishments as a breeder would eventually match those as an art collector. With the goal of mixing French and American thoroughbred lines, in 1929 he purchased a 175-acre farm called Walnut Springs near Lexington, Kentucky. Subsequently, he moved his operation to Virginia, settling on a large parcel of land in Upperville on which he built a house called Sundridge (fig. 11). In 1930 Clark also bought a 44-acre farm in Normandy that included a picturesque

Fig. 11
Sterling *(far right)* and Francine Clark *(second from left)* with friends at Sundridge, 1948

Fig. 12
Sterling Clark's racehorse, Never Say Die (*front left*, ridden by Lester Piggott), won England's Epsom Derby in 1954. Paul Popper/Popperfoto/Getty Images

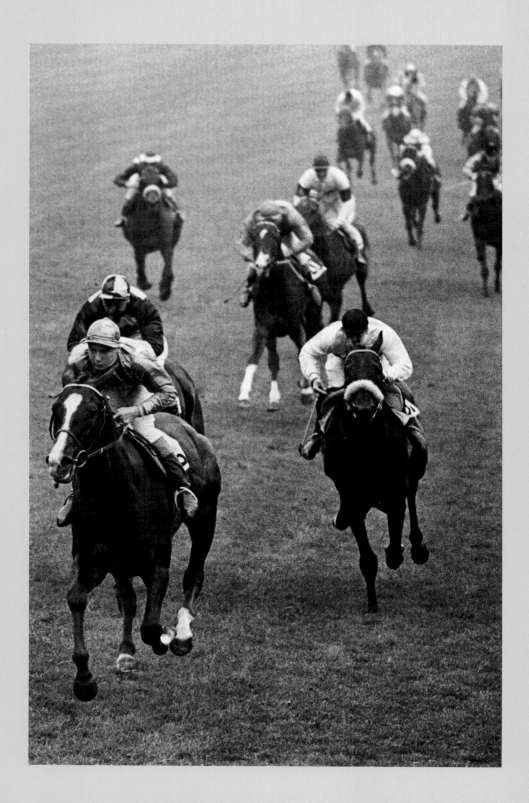

manor house named La Lisière. His complex and ingenious horse-breeding efforts would be rewarded in 1954, when his prize thoroughbred, Never Say Die, became the second American-bred horse to win the England's prestigious Epsom Derby (this was also the first race won by the eighteen-year-old jockey Lester Piggott, who became the most famous jockey in Britain during the late twentieth century; fig. 12).

Despite Clark's good-natured art market competitiveness, he developed a number of close relationships with other American collectors, notably John T. Spaulding of Boston and Chester Dale of New York. Clark saw in Dale a collector like himself who chose to follow his own instincts over received opinions. "A picture has to do something to his insides for him to buy it," Clark once noted approvingly. Like his collector friends, however, for Sterling works of art represented more than just objects of aesthetic value. He took great delight in finding works that were undervalued in the marketplace, and he gleefully noted whenever his paintings appreciated in monetary terms, which he took as affirmation of his own judgment. "Heaven knows what my finest Renoirs are worth!!!!" he wrote in his diary. "I should say [they] have doubled in value at least!!!! As to 'la Fille au Crochet' [*A Girl Crocheting*]…it is worth at least 5 times what I paid for it!!!!" In one notable instance, Sterling visited Durand-Ruel, one of his favorite Parisian dealers, to decline the dealer's offer of Renoir's *Blonde Bather*, which he felt was proposed at too high a price. After the dealer persuaded him to take a second look, Sterling cited the exact prices of several recent Renoir sales. In the end, the dealer was persuaded to offer a sharp reduction in order to encourage the purchase, keeping Clark as a valued client in the process.

The purchase of Toulouse-Lautrec's stunning painting *Jane Avril* (see cat. 39) highlights the important influence that Francine had on the Clark collection. The couple's collecting relationship was later memorialized by the artist Paul Clemens, who depicted the Clarks seated close together and looking at their drawings at Durand-Ruel Galleries where they had stored many of their works of art (fig. 13). On a visit to Wildenstein's in New York in February 1940, the couple encountered *Jane Avril* and Sterling noted that he "could see that Francine was impressed and very much so. I asked how much—Felix Wildenstein said $45,000 to me, asking $55,000…expensive yes but a fancy picture…Francine was very strong for buying 'Jeanne Avril' [*sic*]—A 'chef

d'oeuvre' she said." Discussing it as they left the dealer's, the couple did not make it far before they decided to return and buy it. Sterling mused: "Home—never saw Francine more enthusiastic over a picture!!!!" In many of his diary

Fig. 13
Paul Lewis Clemens (American, 1911–1992), *Mr. and Mrs. Clark*, 1967, after a 1942 original. Oil on canvas, 19³⁄₁₆ × 14¼ in. (48.7 × 36.2 cm). Sterling and Francine Clark Art Institute, Williamstown, Massachusetts (1967.84)

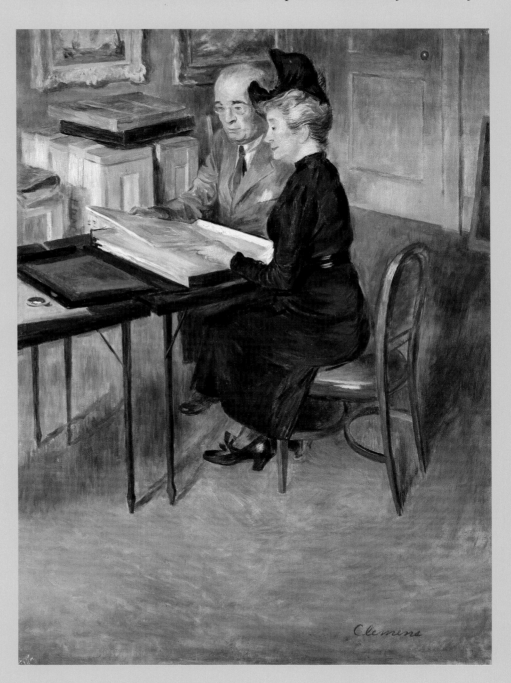

entries Sterling records Francine's reactions to the works they encountered, and it is clear that he valued her opinion highly. The dealer Norman Hirschl later recounted that Francine, in her own quiet way, was often the one with stronger opinions.

In the late 1930s, as war loomed once again in Europe, Clark focused on safeguarding his collection. With the help of his dealer friends he was able to crate the most important works from his Paris home in the summer of 1938. In his diary he noted, "What times with the cursed airplanes & the terrible material destruction ahead of us all of so many beautiful things!!!—It made me sad to think of how much has left the house—Collections of 30 odd years—No rest for the weary." The Clarks visited Paris again in the summer of 1939 but did not return until 1946. Most of the Paris collection was destined for Montreal and Denver, which the Clarks had been advised would be well out of the way of the conflict. Sterling set up a gallery at the Royal Bank of Canada in Montreal, and many of the couple's paintings remained there until the mid-1950s, when the collection was installed at the Williamstown museum.

In the United States, the Clarks divided their time between a new apartment at the Ritz-Carlton and their farm in Virginia. They had begun buying silver and porcelain in the 1920s and '30s, and in the spring of 1940 they mounted an exhibition of their silver collection at the Crichton Company gallery in New York. They were convinced to do so by the gallery's manager, Peter Guille, who had quickly become the couple's favorite silver dealer. The exhibition opened in June with a dollar admission charge that would benefit English and French war-relief organizations. The outcome delighted the couple, as it gave them the first opportunity to see their objects installed together. Three years later, Sterling mounted another exhibition, this time at the Durand-Ruel Galleries in New York, to support Free French Forces. Instead of decorative arts, however, the 1943 exhibition comprised just one monumental painting: William-Adolphe Bouguereau's *Nymphs and Satyr* (see cat. 58). The publicity-shy Sterling remained an anonymous lender for both exhibitions, although he was no doubt inspired by the positive reaction they received.

When the Clarks returned to Paris in 1946, they surveyed their house, which their two housekeepers had maintained throughout the war years. The war had shattered their former Parisian life—their best things were in storage, their house was somewhat forlorn, the city they had known and loved was

facing years of postwar reconstruction, and their farm in Normandy had been bombed and completely destroyed two years earlier. They decided to sell the house on rue Cimarosa. The pace of new acquisitions slowed considerably in the years following the war, with only three or four paintings added per year between 1948 and 1955. It was in this period, shortly after the war, that Sterling began to think more seriously than ever about the permanent future of his collection.

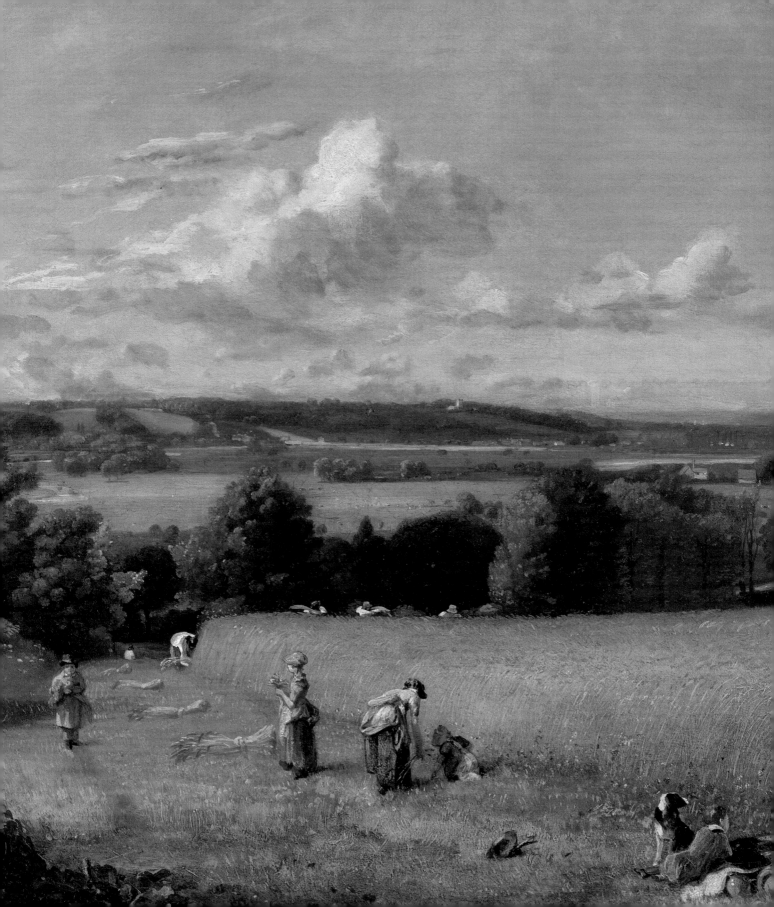

A Sense of Place

The natural world and the urban environment have been fruitful subjects for artists throughout the centuries. The Clark's collection includes paintings, drawings, and photographs that explore the theme of landscape—real and imagined, symbolic and spiritual—and celebrate the unique character of cities like Paris, Rome, Venice, and New York. These images include sensitive evocations of rustic life and dramatic views of the awesome power of the elements. They may be topographical scenes, poetic inventions, or meditations on the relationship between human beings and nature. Whether inspired by the pastoral beauty of rural France or England, the rocky coast of Maine, the wide open spaces of the American West, or the backstreets of a city, the works represented here help us to see the world around us with fresh eyes.

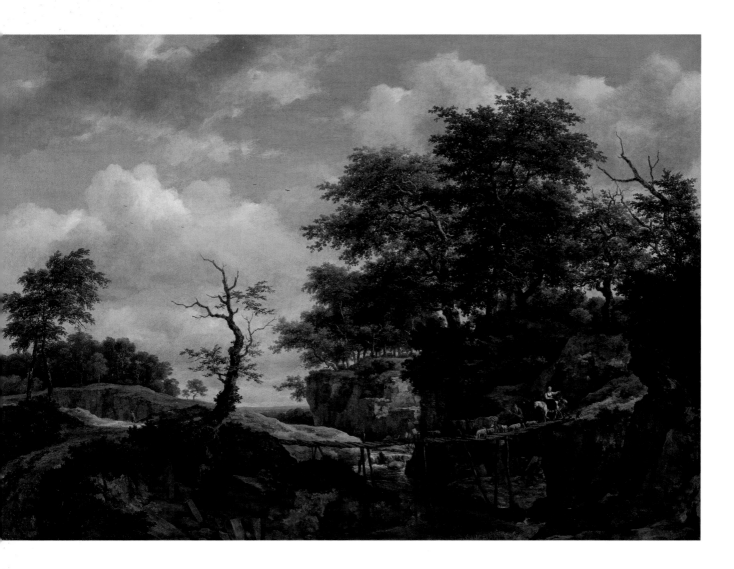

1. **Jacob van Ruisdael** (Dutch, 1628/9–1682)
Landscape with Bridge, Cattle, and Figures, c. 1660
Oil on canvas, 37⅝ × 51¹/₁₆ in. (95.6 × 129.7 cm)
Acquired by Sterling and Francine Clark, 1922, 1955.29

Jacob van Ruisdael may have been the most accomplished landscape painter in the Netherlands in the seventeenth century. The countryside in this great painting is probably invented rather than topographical, though Ruisdael's profound understanding of landscape forms and atmospheric effects is wonderfully convincing. The river flows between rocky banks that are crowned by trees, young and old. The twisted limbs of a dead tree are outlined against the white clouds, and beneath its roots several rectangular stones resemble markers in a derelict burial ground. Figures and animals cross the footbridge with understandable trepidation, given its unstable appearance. Viewed one after another, these details begin to take on deeper significance. Ruisdael sometimes included thinly veiled references to the passage of time and the inevitability of death in his paintings; however, for the artist and his patrons mortality was not the end of the story—the figure in red has passed beyond the symbols of death and walks through a green and pleasant land.

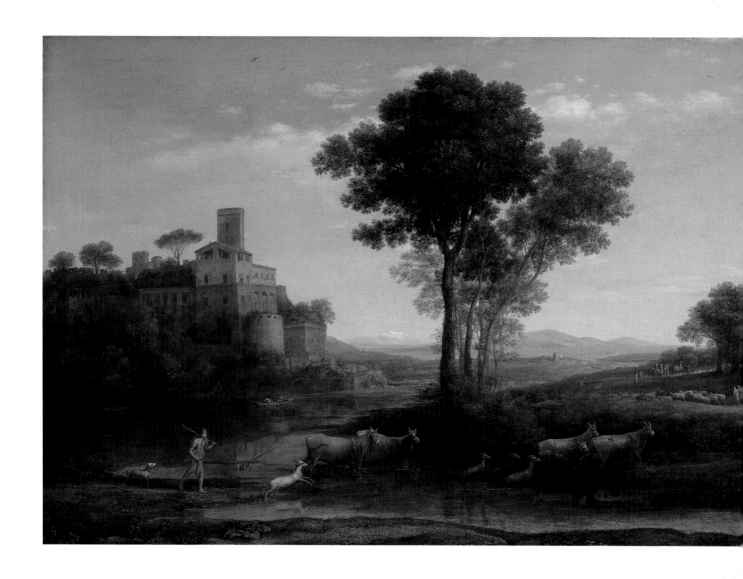

2. **Claude Lorrain** (French, 1604/5–1682)
Landscape with the Voyage of Jacob, 1677
Oil on canvas, 28¹⁄₁₆ × 37⁷⁄₁₆ in. (71.2 × 95.1 cm)
Acquired by Sterling Clark, 1918, 1955.42

The French artist Claude Lorrain spent most of his career in
Italy drawing and painting idyllic landscapes inspired by the
countryside around Rome. In *Landscape with the Voyage of Jacob*
the various components of the image are based on the artist's
observation of the natural world; but like a great poet, Claude
has combined them in a graceful, abstract structure. The river
flows across the foreground and reflects the castle before
changing direction and passing behind an elegant group of
trees, leading our eyes toward the horizon. Jacob's caravan
follows a similar winding path across the river and off into
the distance on the right. Most of Claude's paintings have
narrative subjects, but the beauty of his work owes less to
the subject matter and more to the use of golden light and a
lyrical reordering of naturalistic details.

3. **Théodore Rousseau** (French, 1812–1867)
Farm in the Landes, 1844–67
Oil on canvas, 25½ × 39 in. (64.8 × 99.1 cm)
Acquired by the Clark, 2009, 2009.8

In 1844 Théodore Rousseau spent several months in the Landes, in southwestern France. The region was not known, particularly, for its scenic beauty—the French word *lande* means "moor"—but Rousseau seems to have felt that it was a special, almost sacred, place. While there, he made a detailed drawing of a farmyard, and he started work on this painting when he returned to Paris. Unlike the Impressionists, who were fascinated by the transient dappling of light and shade, Rousseau attempted to record not only a landscape's visual appearance but also its essential character. He worked on this painting off and on for more than twenty years, refining the surface obsessively and making subtle alterations to the foreground, farmyard, foliage of the oak trees, and warm sunlight that unites the composition. Rousseau retained the work, even after the collector Frédéric Hartmann bought it, and Hartmann did not take possession of the painting until after Rousseau's death in 1867.

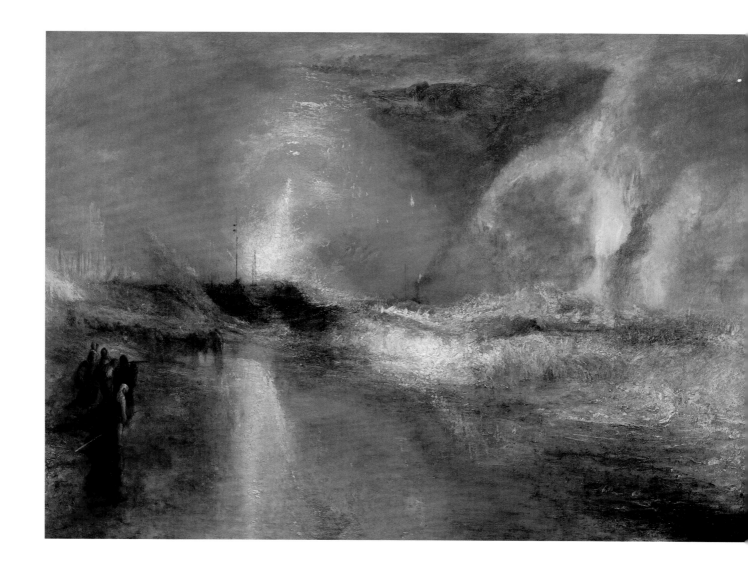

4. **Joseph Mallord William Turner** (English, 1775–1851)
Rockets and Blue Lights (Close at Hand) to Warn Steamboats of Shoal Water, 1840
Oil on canvas, 36¼ × 48⅛ in. (92.1 × 122.2 cm)
Acquired by Sterling and Francine Clark, 1932, 1955.37

Joseph Mallord William Turner greatly admired the work of Claude Lorrain (see cats. 2 and 51), and many of his paintings retain the classical harmony of Claude's landscapes. But Turner also explored more dramatic subjects that often involved human beings struggling against the elements. *Rockets and Blue Lights* depicts a storm raging in an English harbor town. Flares explode in the sky to alert ships to the location of shallow water, as a group of huddled spectators stands at the water's edge. Buffeted by the wind and rain, they stare out to sea, anxiously hoping that their loved ones will make it safely to shore. This painting offers hope to the suffering human beings it depicts. *Rockets and Blue Lights* suggests at least a chance of rescue from the terrible power of nature.

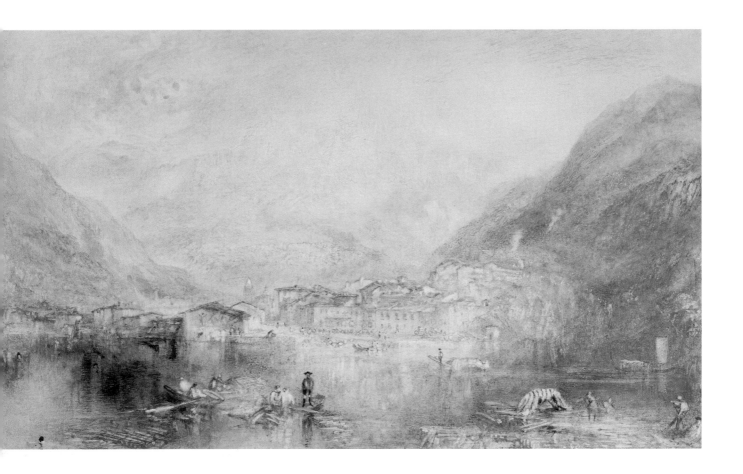

5. **Joseph Mallord William Turner** (English, 1775–1851)
Brunnen from the Lake of Lucerne, 1845
Watercolor and gouache on paper, 11⁷/₁₆ × 18³/₄ in.
(29 × 47.7 cm)
Acquired by Sterling and Francine Clark, 1941, 1955.1865

As teenagers, Turner and Thomas Girtin (cat. 6) studied at an informal "academy" run by Dr. Thomas Monro, a medical professional and collector of drawings and watercolors. Like Girtin, Turner became an exceptionally accomplished watercolorist. Exploiting the unique translucency of the medium, Turner made quick, atmospheric sketches—sometimes in very inclement conditions—as well as more finished works like this view of Brunnen in the Swiss Alps. The buildings of the little town cling to the shore of Lake Lucerne, their whitewashed walls reflected in the water. Above them, majestic mountain peaks dissolve into the blue and gold light of the sky. Though small in scale, Turner's watercolor captures a sublimely beautiful view with appropriate Romantic awe.

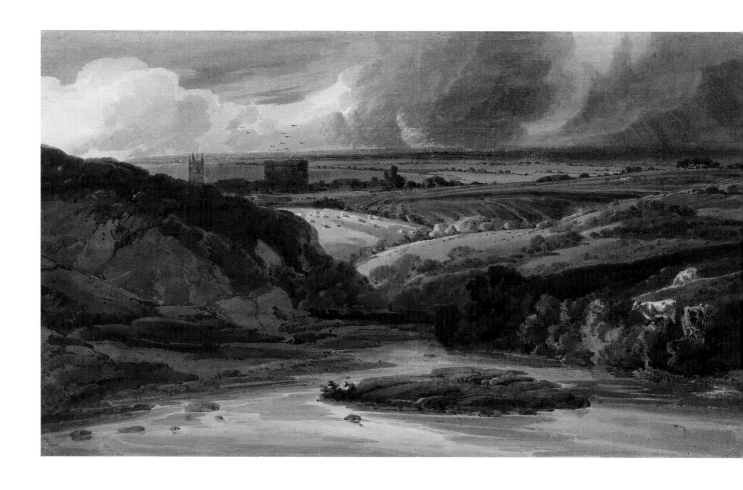

6. **Thomas Girtin** (English, 1775–1802)
Lydford Castle, 1800
Watercolor and gouache over graphite on paper, 12½ × 20½ in.
(31.8 × 52.1 cm)
Gift of the Manton Art Foundation in memory of Sir Edwin
and Lady Manton, 2007, 2007.8.87

Thomas Girtin traveled extensively around Britain painting
highly finished watercolors of the countryside and archi-
tectural subjects, such as Lindisfarne Priory and Durham
Cathedral. This painting contrasts the squat shape of the
forbidding castle with the graceful tower of the nearby church
surrounded by rolling hills, meandering streams, golden
meadows, and plowed fields. Lydford Castle was used for
centuries as a prison, and its location, on Dartmoor, was a set-
ting for many unnerving supernatural tales. Though Girtin has
included no specific references to the dark history of the castle,
the black clouds above the idyllic panorama add a Romantic
sense of brooding drama to the image. The moor may be
picturesque on a good day but it might be an uncomfortable
place to find oneself in bad weather or after nightfall.

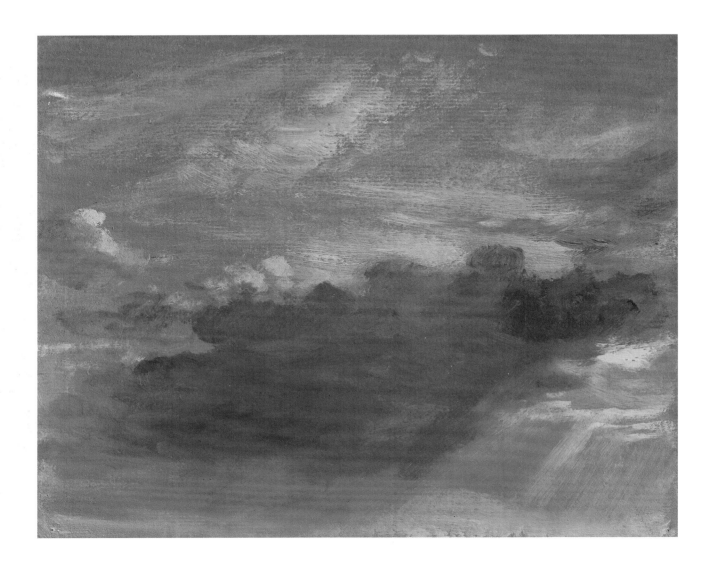

7. **John Constable** (English, 1776–1837)
Cloud Study, c. 1821–22
Oil on cream laid paper, mounted on canvas, 10¹³/₁₆ × 12⁷/₈ in.
(27.5 × 32.7 cm)
Gift of the Manton Art Foundation in memory of Sir Edwin
and Lady Manton, 2007, 2007.8.34

John Constable once described the sky as "the chief Organ of
sentiment" in a landscape. Coming from the relatively flat
county of Suffolk, Constable would have been well acquainted
with views in which the sky was a significant feature. He
made this and many other oil studies while he was living near
Hampstead Heath, and he probably painted it while the paper
was pinned to a rigid board, as pinholes are visible in the
corners. Constable's cloud studies—which record atmospheric
conditions with an almost scientific, analytical eye—helped
him to establish a coherent balance between light and dark in
the paintings he made later in his studio. They provided him
with a visual key, parallel to the dominant key around which a
musical composition is structured.

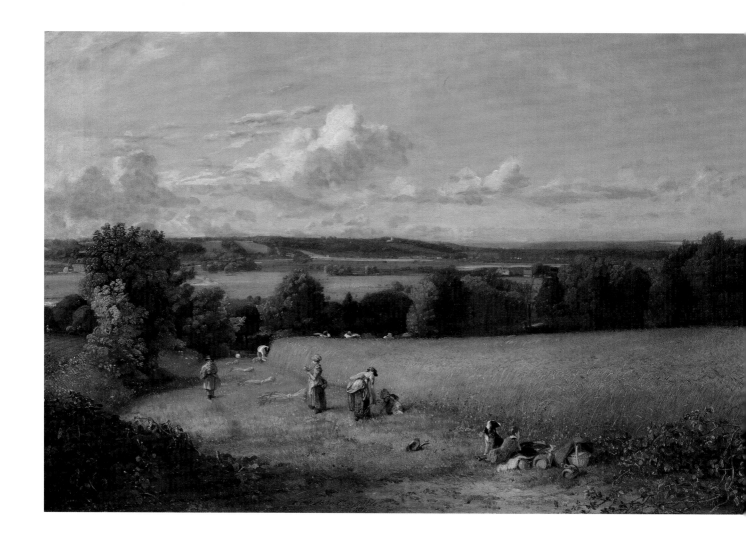

8. **John Constable** (English, 1776–1837)
The Wheat Field, 1816
Oil on canvas, 21½ × 30¾ in. (54.6 × 78.1 cm)
Gift of the Manton Art Foundation in memory of Sir Edwin
and Lady Manton, 2007, 2007.8.27

Constable consistently returned to his native Suffolk, drawing
inspiration from the pastoral landscape of East Anglia. The son
of a prosperous mill owner, he was familiar with the various
rural activities associated with the changing seasons. *The Wheat
Field* depicts several stages in the harvest: men at the far edge
of the field cut down wheat and gather the stalks into sheaves
to be carted to the mill while young women and girls pick up
ears of wheat that the sweeping scythes missed. In the fore-
ground, a boy and his dog sit patiently, guarding the workers'
lunch. Constable painted this picture out of doors, painstak-
ingly recording color, light, cloud formations, and atmospheric
conditions as well as the methodical work of the farm laborers.

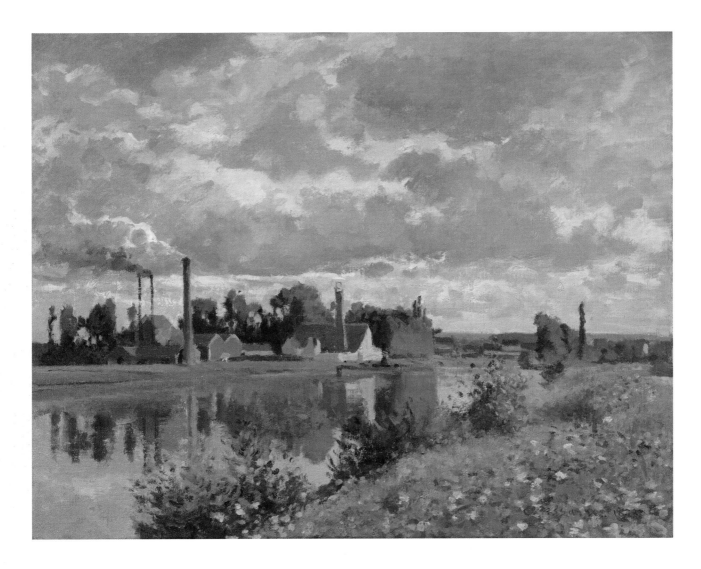

9. **Camille Pissarro** (French, 1830–1903)
The River Oise near Pontoise, 1873
Oil on canvas, 18⅛ × 21¹⁵⁄₁₆ in. (46 × 55.7 cm)
Acquired by Sterling and Francine Clark, 1945, 1955.554

Camille Pissarro's small, vibrant painting of factory buildings on the bank of the River Oise may have seemed aggressively modern to some of his contemporaries, especially those accustomed to images like Bouguereau's *Nymphs and Satyr* (see cat. 58), which was painted in the same year. The buildings in Pissarro's painting are reflected hazily on the slowly flowing river, and the smoke from their chimneys blends with the clouds, adding darker tones to the subtle shades of gray, blue, and white. Like Monet, Pissarro spent the months of the Franco-Prussian War in London, where he saw and admired the work of Constable, Turner, and other English landscape painters. On his return to France after the war, Pissarro settled in Pontoise, a community northwest of Paris, where he painted this scene, probably in the open air and perhaps in one painting session. Though his choice of subject and handling of paint were radically, excitingly avant-garde, his composition is essentially traditional—the skyline divides the image into the same mathematically satisfying proportions as the horizon in a landscape by Claude (see cat. 2).

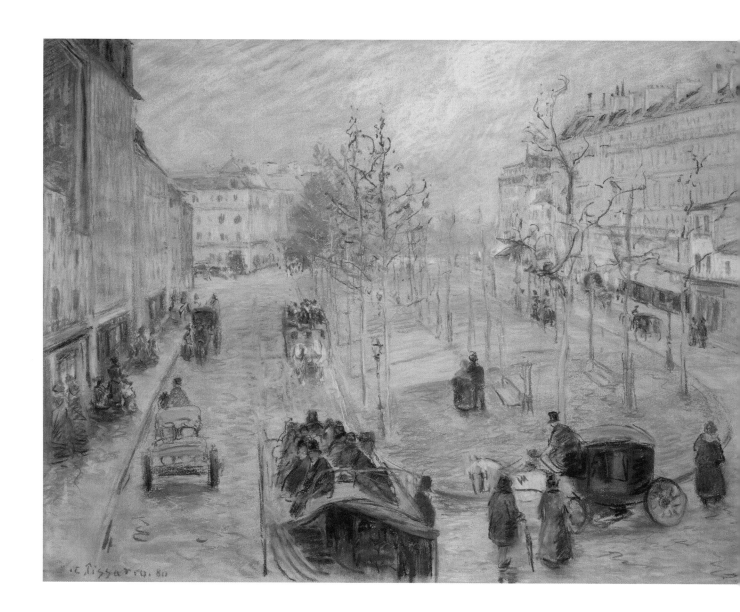

10. Camille Pissarro (French, 1830–1903)
Boulevard Rochechouart, 1880
Pastel on paper, 23⁹⁄₁₆ × 28¹⁵⁄₁₆ in. (59.9 × 73.5 cm)
Acquired by the Clark, 1996, 1996.5

Though Pissarro is known as a painter of rural subjects, he also turned his attention to the urban environment. *Boulevard Rochechouart* is an ambitious composition—its elevated viewpoint presents a bustling Parisian street on a cold winter's day.

Rows of spindly trees cast pale blue shadows across the avenue, alternating with patches of thin yellow sunshine that subtly brighten the chilly city. Buildings enclose the space to the left and right, their roofs a solid blue against the cloudy sky. The artist's hand moved quickly across the paper, leaving behind confident, calligraphic strokes of color that capture the movement of vehicles and pedestrians in real time. The finished picture has the energy of a still from a documentary film about life in the city.

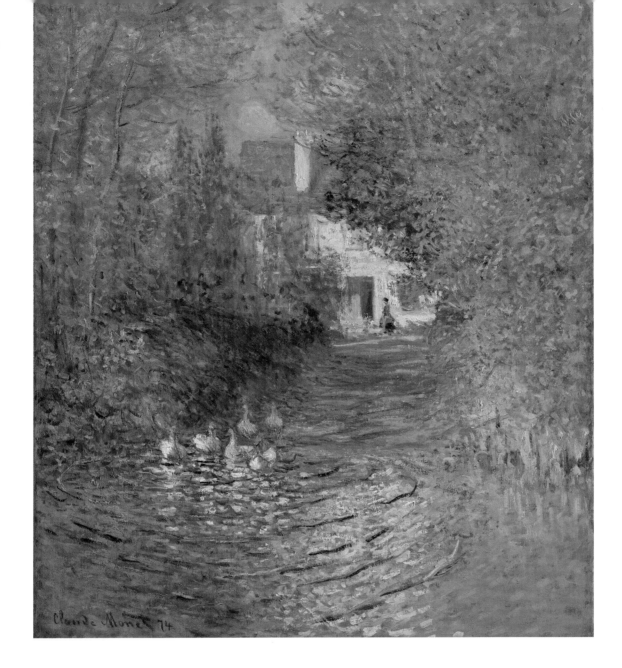

11. **Claude Monet** (French, 1840–1926)
The Geese, 1874
Oil on canvas, 29 × 23⅝ in. (73.7 × 60 cm)
Acquired by Sterling and Francine Clark, 1949, 1955.529

In 1871 Claude Monet moved to Argenteuil, on the Seine, where he painted boats, bridges, and the fields beyond in all seasons and weather conditions. The figures in this painting are almost certainly Monet's wife and young son in their garden. A dazzling light bathes the whitewashed wall of the house and its orange roof. Everything else in the painting seems to be in motion: the eponymous birds wade into the water in the foreground, sending ripples across the surface, and the trees—ablaze with the colors of autumn—shiver in a light breeze. The vertical format of the painting is unusual for this period in Monet's career, and the painting process may have been unusual too. Holes in the corners of the canvas suggest that Monet may have pinned it to a rigid support while he painted, attaching it to a stretcher only when he considered it finished.

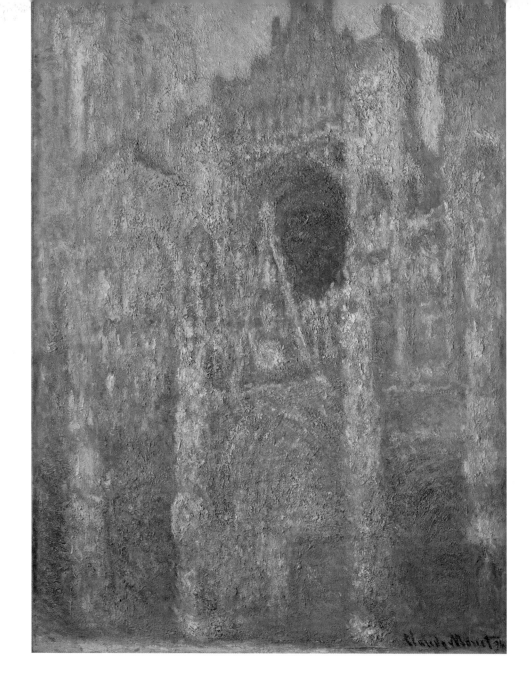

12. **Claude Monet** (French, 1840–1926)
Rouen Cathedral, the Façade in Sunlight, c. 1892–94
Oil on canvas, 42 × 29 in. (106.7 × 73.7 cm)
Acquired by the Clark in memory of Anne Strang Baxter, 1967, 1967.1

In 1892 and 1893, Monet made several extended visits to Rouen, in Normandy, to work on his famous series of paintings of the city's Gothic cathedral. The Clark's picture shows the building in full sunlight. Close examination of the work reveals a thickly textured surface—an encrusted carapace of paint that makes the medieval architecture disappear beneath veils of color. When viewed from some feet away, the paint marks coalesce, the arched portals of the building's west façade become visible, and the massive towers appear, soaring into the sky. Monet painted around thirty images of the cathedral in various weather conditions and at different times of day. He exhibited twenty of those canvases in Paris in 1895.

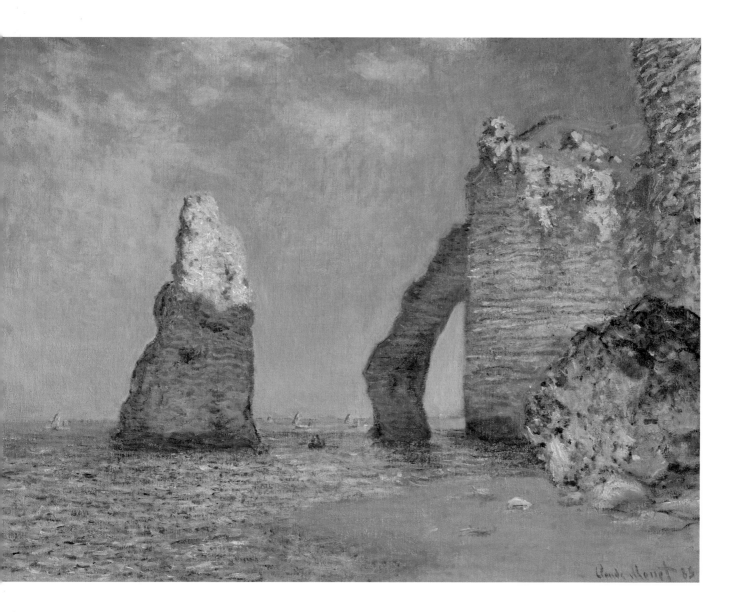

13. **Claude Monet** (French, 1840–1926)
The Cliffs at Étretat, 1885
Oil on canvas, 25⅝ x 32 in. (65.1 x 81.3 cm)
Acquired by Sterling and Francine Clark, 1933, 1955.528

The village of Étretat, with its picturesque rock formations, attracted a variety of artists in the nineteenth century, including Delacroix, Courbet, and Boudin. Monet himself painted and drew the cliffs many times, on this occasion looking east from a narrow stretch of beach rather than the more familiar view from the village on the other side of the eroded arch. Warm sunlight and cool shadows bathe the stratified layers of stone, and fishing boats—small and relatively insignificant in the awe-inspiring setting—sail in and out of the harbor. Monet focused on light, color, and texture—thinly painted clouds float in the blue sky, while thicker paint marks suggest both the solid mass of the cliffs and the undulating surface of the water.

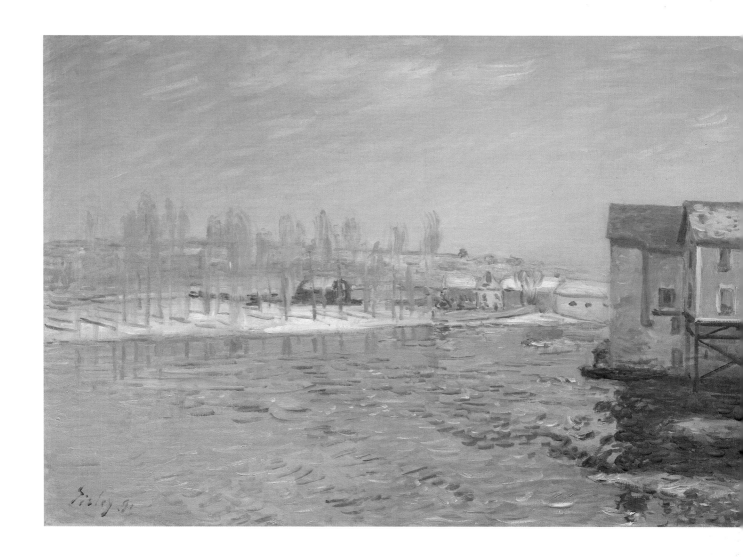

14. Alfred Sisley (English, 1839–1899)
The Loing and the Mills of Moret, Snow Effect, 1891
Oil on canvas, 23⅛ × 32⅛ in. (58.7 × 81.6 cm)
Acquired by Sterling and Francine Clark, 1946, 1955.545

In 1880 Alfred Sisley and his family moved from Paris to
Moret-sur-Loing, a small town south of the capital, where life
was less expensive. This painting, which records the weather
in transition, was made during an unusually cold winter. Trees
on the riverbank cast blue shadows on the snow and their
trunks are reflected on the ice. In midstream, the river flows
past the mill buildings, one of which seems to be in opera-
tion—the lack of snow on its roof suggests activity and warmth
within. Charming, subtle, and undemonstrative, Sisley's paint-
ings are faithful to the defining principles of Impressionism.
Throughout his career he captured the specifics of light,
atmosphere, and location with the finely tuned perception of a
pastoral poet.

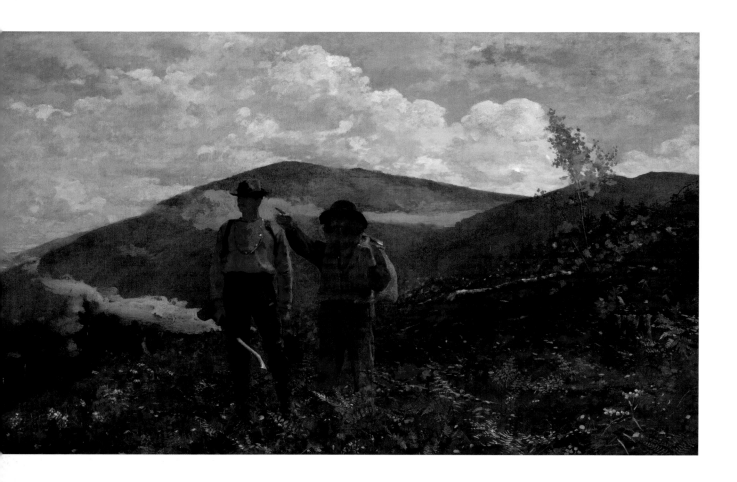

15. **Winslow Homer** (American, 1836–1910)
Two Guides, 1877
Oil on canvas, 24¼ × 38¼ in. (61.6 × 97.2 cm)
Acquired by Sterling Clark, 1916, 1955.3

Winslow Homer's *Two Guides* reflects the artist's deep affection for the Adirondack Mountains in New York. The man on the left in the red shirt is a mountain guide named Charles Monroe Holt, and the one on the right is Orson Phelps, a well-known "character" of the area. Sunlight gleams on the blade of Phelps's axe and the curve of Holt's axe handle.

Together they survey the landscape with confident, knowing eyes. The hillside on which the men stand may look like untamed wilderness, but the guides are perfectly comfortable amid the stumps of trees, tangle of undergrowth, and glowing autumnal colors—their axes seem to suggest that they are in control of the environment. Homer was a frequent visitor to the region, which offered him plentiful opportunities for hunting and fishing as well as endless subjects for watercolors and oil paintings that explore one of his favorite themes—human beings interacting with the natural world.

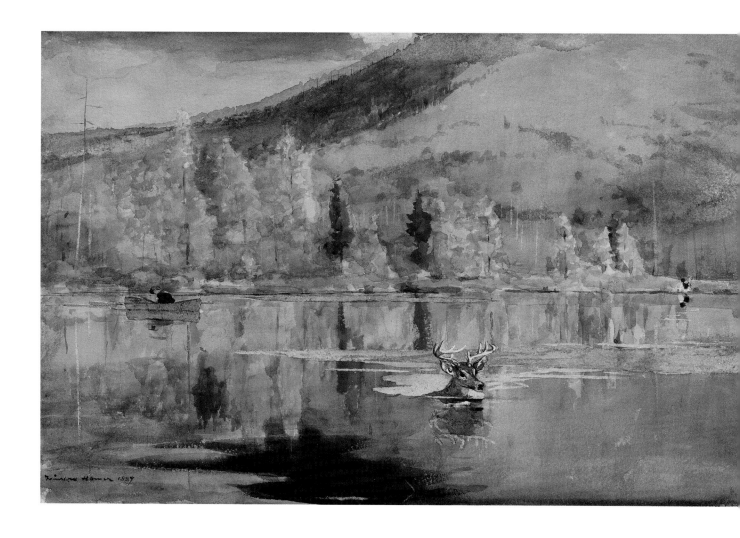

16. **Winslow Homer** (American, 1836–1910)
An October Day, 1889
Watercolor over graphite, with scraping, on paper, 14¹⁄₁₆ ×
19³⁄₄ in. (35.7 × 50.2 cm)
Acquired by Sterling and Francine Clark, 1947, 1955.770

In 1888 Homer became a member of the North Woods Club,
which is located between Glens Falls and Lake Placid in upstate
New York. During the next few years he painted dozens of
luminous watercolors of the region's lakes and mountains as
well as the men who fished and hunted there. *An October Day*
depicts a deer that a hound has pursued into a lake so that the
man in the canoe can kill it, a method of hunting that was
controversial at that time. Homer's drawing represents the
scene objectively, without revealing any opinion on the subject.
His watercolor technique is masterful—golden trees line the
lake shore, their reflections broken by areas of paper that have
been scraped free of pigment and repainted to indicate the
movement of the deer through the water.

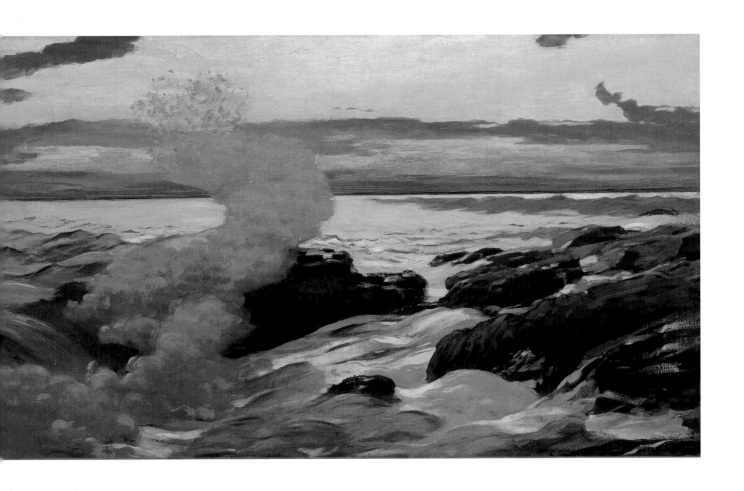

17. **Winslow Homer** (American, 1836–1910)
West Point, Prout's Neck, 1900
Oil on canvas, 30^1/$_{16}$ × 48^1/$_8$ in. (76.4 × 122.2 cm)
Acquired by Sterling and Francine Clark, 1941, 1955.7

18. *Eastern Point*, 1900
Oil on canvas, 30^1/$_4$ × 48^1/$_2$ in. (76.8 × 123.2 cm)
Acquired by Sterling and Francine Clark, 1954, 1955.6

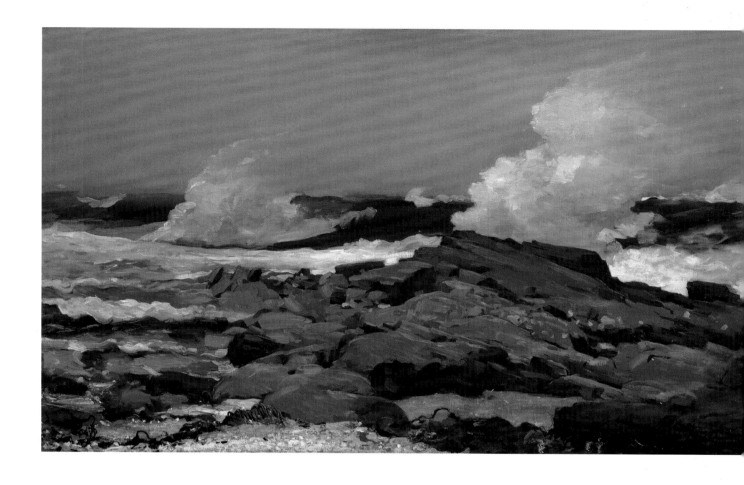

In the mid-1880s Homer settled in Prout's Neck, just south of Portland, Maine. There he repeatedly painted the unique character of the local coastline, with its ever-changing weather conditions. Foaming waves crash against the rocks in *West Point, Prout's Neck*, sending up a spray of seawater that cuts across the horizontal red glow of the setting sun. Though the straight line of the horizon is the dominant feature of this composition, writhing paint marks in the foreground flow in a series of overlapping, undulating diagonals and thick strokes of white tinted with pink reflect the disappearing light. Waves surge over and between the red-brown boulders, soaking the stones and enriching their color. The Clarks bought the pendant painting *Eastern Point* in 1923, but sold it again later in the decade, only to repurchase it after acquiring *West Point, Prout's Neck*.

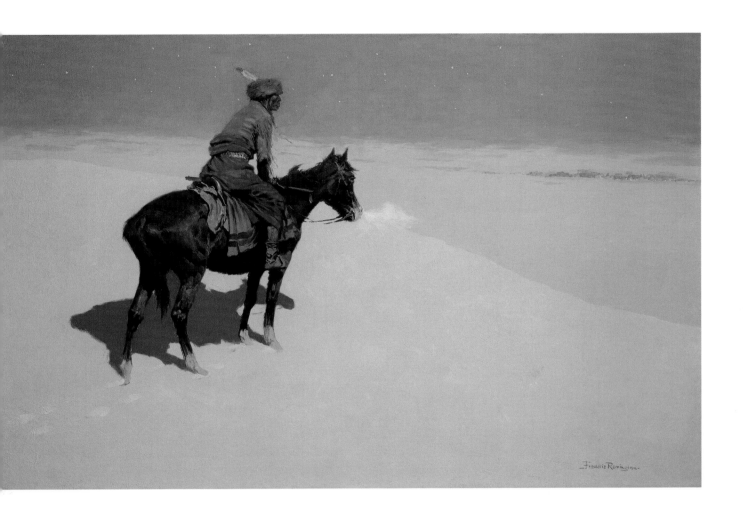

19. **Frederic Remington** (American, 1861–1909)
Friends or Foes? (The Scout), 1902–05
Oil on canvas, 27 × 40 in. (68.6 × 101.6 cm)
Acquired by Sterling and Francine Clark, 1951, 1955.12

Frederic Remington was a famous chronicler of the American West, despite the fact that he spent most of his adult life living and working in New York and Connecticut. He made many extended visits to the West, drawing and photographing details of life in the territories. Those visits may have influenced a change in Remington's views toward Native Americans, as later in his career he became more sympathetic to their plight.

One of the artist's most haunting images, *Friends or Foes? (The Scout)* depicts a Blackfoot Indian alone on a scrawny horse and staring across a freezing, snowy plain. The moonlight is bright—horse and rider cast a clearly defined shadow across the ground—but there is no warmth in it. The night is cold and the environment is bleak: the horse's hoof prints are visible in the snow, and its breath steams in the chill air. The painting presents the dilemma of Native Americans with a degree of human understanding—the distant camp must look very attractive, but the scout is clearly unsure if he would be welcome there. His back is arched with uncertainty—his need for shelter tempered by the possibility of a hostile reception.

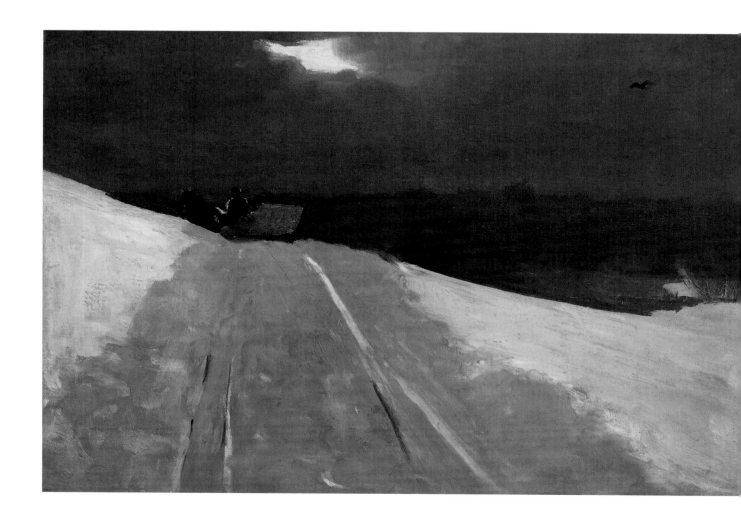

20. **Winslow Homer** (American, 1836–1910)
Sleigh Ride, c. 1890–95
Oil on canvas, 14¹⁄₁₆ × 20¹⁄₁₆ in. (35.7 × 51 cm)
Acquired by Sterling and Francine Clark, 1944, 1955.771

Though small in scale and with fewer details than many of his other landscapes, Homer's *Sleigh Ride* remains a distinctly powerful image. The sloping line of the hillside divides the canvas into two almost perfectly equal halves. The runners of the sleigh have scored tracks in the snow that lead our eyes up to the sleigh itself, which carries its passengers over the crest of the hill and out of sight. In the top half of the painting, a rich deep blue fills most of the sky, as a single dazzling ray of moonlight breaks through to illuminate the scene. The painting is not signed or dated, and it was not sold or shown in an exhibition during Homer's lifetime. Perhaps he intended it as an experimental study of light and atmosphere, or it may have had more personal meaning for him. The strikingly modern composition and subtle, but dramatic, use of color are wonderfully evocative of a cold winter's night in New England.

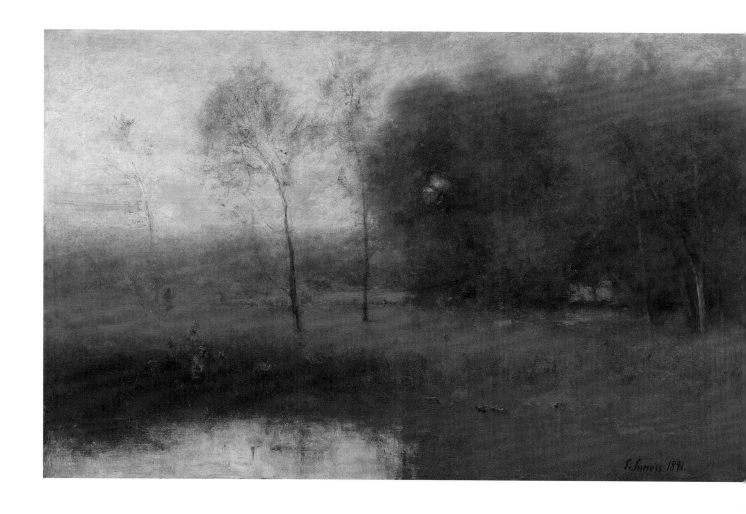

21. **George Inness** (American, 1825–1894)
New Jersey Landscape, 1891
Oil on canvas, 30 × 45 in. (76.2 × 114.3 cm)
Gift of Frank and Katherine Martucci, 2013, 2013.1.7

A delicate sun sits just above the line of trees on the left of the canvas, shedding pale light across the misty landscape. The finely modulated colors—greens, ochers, grays, and blues— were painted with a brush and then wiped with a cloth, so that they blend into each other without contours. The artist added linear accents with the rigid tip of his brush, softly incising the lines of tree trunks and branches into the paint layer. A follower of the Swedish philosopher Emanuel Swedenborg, Inness felt that landscape paintings were visual meditations— reflections of the spiritual essence that lay beneath superficial appearance.

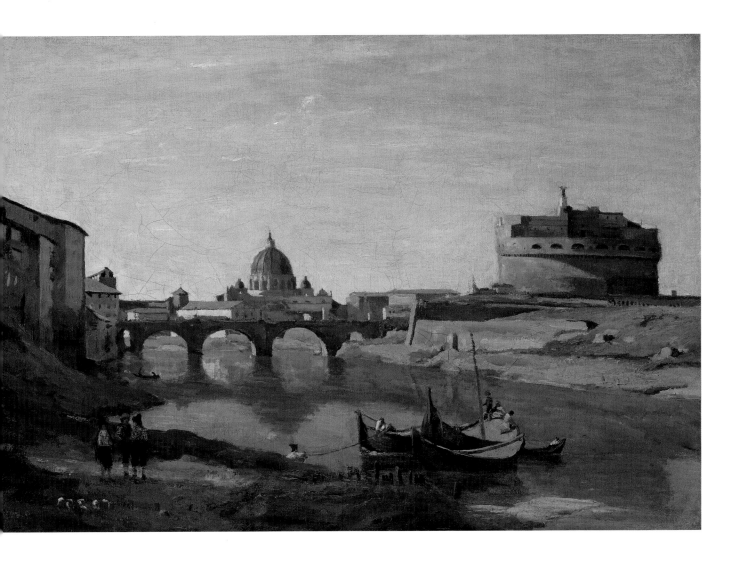

22. Jean-Baptiste-Camille Corot (French, 1796–1875)
Castel Sant'Angelo, Rome, c. 1830–32
Oil on canvas, 13 1/2 × 18 in. (34.3 × 45.7 cm)
Acquired by Sterling and Francine Clark, 1946, 1955.555

Jean-Baptiste-Camille Corot's painting of the Castel Sant'Angelo in Rome has the coherence of a study done in one session; afternoon sunlight, cool shadows, and shimmering reflections tie the various elements of the painting—land, architecture, sky, and water—together. In fact, Corot may have worked on the canvas over a longer period of time. The round arches of the bridge echo the shape of the dome of Saint Peter's, which seems to float above the city, gracefully contrasting with the massive bulk of the ancient structure on the right. Built originally by the Roman Emperor Hadrian as his mausoleum, the Castel Sant'Angelo was taken over by the papacy in the fourteenth century and used by various popes as a refuge in times of trouble. At other times it was a political prison. One of its most famous inmates was the fictional artist Cavaradossi, whose lover Tosca throws herself from the roof of the castle at the end of Puccini's opera.

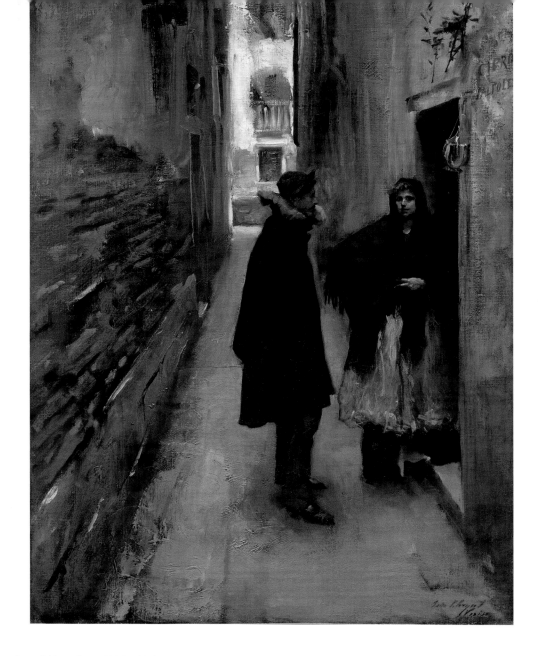

23. John Singer Sargent (American, 1856–1925)
A Street in Venice, c. 1880–82
Oil on canvas, 29⁹/₁₆ × 20⁵/₈ in. (75.1 × 52.4 cm)
Acquired by Sterling and Francine Clark, 1926, 1955.575

John Singer Sargent's visits to Venice in 1880 and 1882 resulted in several oil paintings and watercolors of subjects that were uniquely Venetian, but not typical of the images painted by other artists. *A Street in Venice* takes us into a narrow passage where no respectable Henry James character would be likely to venture. The man and woman are surely locals, and Sargent seems to be asserting his local knowledge by depicting them in a dark alleyway with flaking plaster walls. The woman's salmon-pink skirt is clearly calculated to attract attention, and her confident expression makes one wonder what her relationship might be to the man in black who follows her into the tavern. The freely applied paint enhances the sense of immediacy—the implication being that the artist is witnessing a live event. While other artists painted Saint Mark's Square and the Grand Canal, carnival masks and gondoliers, Sargent's painting is an image of real life in modern Venice.

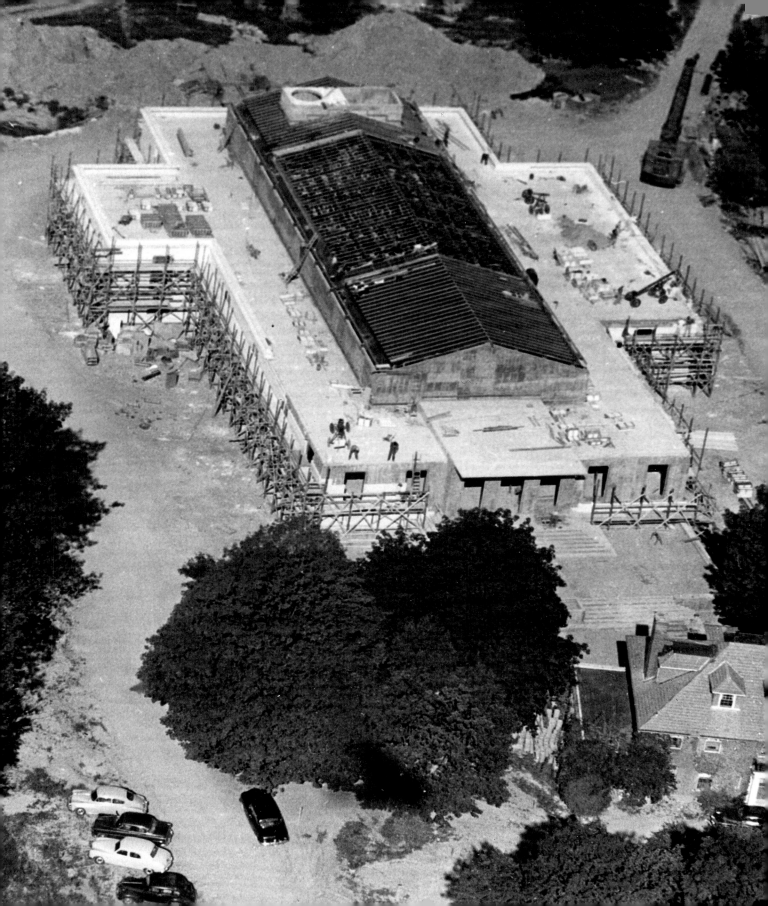

THE ART MUSEUM

On May 17, 1955, Sterling and Francine Clark presided over the opening of their new museum. Before a small crowd of invited guests, Sterling beamed as his wife cut the ribbon, bringing to fruition an idea many years in the making. In one magnanimous gesture, the deeply private collector transferred his collection—unknown at the time even to scholars—into a newly established public institution that today welcomes nearly a quarter of a million people annually. With intimately scaled galleries, a dramatic natural setting, and an intellectual ambition recognized internationally, the Clark cultivates personal experiences through works of art and programs that advance an understanding of the visual arts. Its exceptional collections and groundbreaking exhibitions, innovative research and academic programs, and numerous education and outreach initiatives serve the public regionally and beyond.

The establishment of an art museum in the college community of Williamstown was not Clark's original intention. A sophisticated collector who had spent the summers of his youth in Cooperstown, New York, Clark had long before mused on the creation of a private museum in a rural setting. Writing to his brother Stephen in February 1913, Sterling noted that while the advantages of New York were many (more people seeing the collection would increase its visibility), an art museum in Cooperstown would help the community and ultimately receive more positive attention: "In N.Y. it would be compared with some of the famous collections and some of the best known works of art and would suffer in comparison before the eyes of the common man." Stephen, a generous donor to many art museums, would eventually found more than one institution in Cooperstown, with the goal (as suggested in one of Sterling's early letters) of helping the town generate significant revenue from visitors.

Sterling's intentions for his own collection would vary widely before he settled on an art museum in Williamstown (fig. 1). His change of attitude over the years, however, reflects his interest in providing public access to the collection rather than the establishment of a museum per se. On the eve of his departure from Paris to New York in 1924—after more than a decade living in Paris and five years of marriage to Francine—Clark drew up a will specifying that his Paris house and art collection should be donated to the Petit-Palais, with the rest of his estate going to his stepdaughter, Viviane. Even at that juncture it was clear that Clark saw his collection as an indivisible whole that he wished to make publicly accessible. His intention to leave his collection to a French rather than an American institution underscores Clark's affinity at the time for his adopted home.

Fifteen years later, the impending threat of another world war shaped Clark's thoughts on the future of the collection, as the couple reluctantly decided to leave their Paris home and store their works of art. For Clark, leaving Paris was difficult on both a practical and personal level, as he had come to identify closely with the city in which he had spent so many years. In 1934 the couple moved into a larger apartment in Carlton House next to the Ritz-Carlton Hotel, which could accommodate additional furnishings. During his last visit to Paris in 1939, before the war broke out, Clark rewrote his will, leaving his collection not to a Parisian institution but to the city of Richmond, Virginia, with the understanding that it would be housed at the recently opened Virginia Museum of Fine Arts. Given that the couple spent much of their time at their Upperville farm—which adjoined that of the younger art collector Paul Mellon, a supporter of the new museum in Richmond—Clark's decision was somewhat understandable. Over time, however, as Sterling and Francine spent more time in New York, they recognized the Clark family's long-standing ties to the city, and in 1943 he changed his will once again, bequeathing his collection of rare books to the New York Public Library and his art collection to the Metropolitan Museum of Art, with the stipulation that it remain there as the R. Sterling Clark Collection.

Clark's ties to New York were significant. He had been raised there, and his family had invested in the growth of the city's West Side. Significant philan-thropy initiated by his mother—which continues today through various Clark family foundations—focuses on New York City needs. Clark also had a deep

Fig. 1
Previous page,
Construction of the
Clark Art Institute, 1954

admiration for the Frick Collection on the corner of Fifth Avenue and 70th Street, with its elegant domestic spaces and unobstructed natural light. "It is certainly not only one of the finest collections in the world for quality," he wrote after a visit in 1940, "but it is one of the best for decoration and background." Noting the addresses of several houses that might be available near the Frick, he tried to buy a property at 71st Street and Fifth Avenue that, as he described in his diaries, would always be blessed with natural light (Central Park was to the west and the Frick, to the south, would never build beyond its current height). Eventually, however, Clark acquired three adjacent townhouses at the southwest corner of Park Avenue and 72nd Street. It was there that he intended to renovate the existing structures or build a new museum and install his collection in a fashion suggesting the domesticity of the Frick. With those plans in mind, Sterling changed his will yet again in 1946, making a gift:

> for the purpose of establishing and maintaining a gallery of art and of encouraging and developing the study of the fine arts and advancing the general knowledge of kindred subjects; such gallery of art to be a public gallery to which the entire public shall always have access.

The institution was to be funded through an endowment established for the construction, upkeep, and expansion of the building as well as for "the acquisition of other suitable works of art to form part of such gallery of art, and the maintenance of a non-profit school or schools for the study of the fine arts and kindred subjects."

In the late 1940s, as he entered his seventies, Clark concentrated on plans for his museum. Unlike other American collectors of his time, he had experienced war firsthand, initially as a soldier in China, then in Paris during World War I. Though he had emerged from World War II personally unscathed—save for the destruction of his Normandy farm, La Lisière, by Allied bombers in 1944—the fact that he was forced to move and safeguard his collection during the war years made him reflect more deliberately on what might become of his treasures after his death. According to his friend Paul Clemens, Sterling was highly sensitive to the possibility of loss in a future conflict, and he began to reconsider his plan to establish a museum in New York. During a Caribbean cruise in 1947, Clark admitted his concern about the threat of war,

mentioning the possibility of housing his collection at a safe distance from a major metropolitan area, perhaps in upstate New York or the Berkshires. Thus, he returned to the idea he had proposed to his brother Stephen decades earlier—that of establishing an art museum in a pastoral setting north of New York City.

Two years later, in January 1949, retired Williams College art history professor Karl Weston and his younger colleague S. Lane Faison Jr. paid the Clarks a visit. Astonished by the breadth and quality of the couple's collection, they encouraged Williams President J. Phinney Baxter to invite the Clarks to Williamstown. Baxter was well aware of the longstanding ties between Williams and the Clark family. Sterling's grandfather, Edward, had been a graduate (1831) and major benefactor of the College and Sterling's father, Alfred, had been a trustee. And in 1908 Sterling, his mother, and his brothers had donated a new Clark Hall for the study of geology, which housed mineral collections that Edward had donated to Williams during the 1880s (fig. 2). In the fall of 1949, Baxter invited the Clarks to visit Williamstown and a warm friendship quickly developed.

Spurred by his family's connection to Williams and by a sense of his own mortality, Clark quickly decided to reconsider the location of his proposed

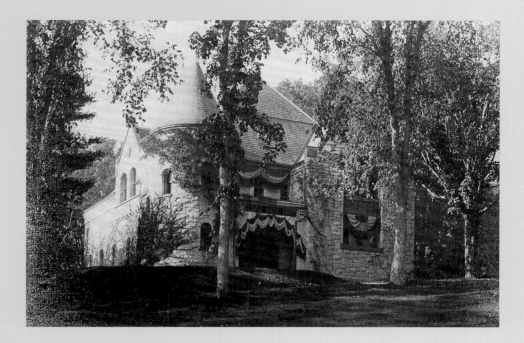

Figs. 2 a–c
Clark Hall at Williams College. *Left*, The original building, gifted by Edward Clark in 1882; *right*, the second building, built in 1908 with funds from Elizabeth Clark and her sons; *far right*, dedication plaque

museum. Within a few weeks of the Clarks' visit, Baxter negotiated a suitable site on South Street, arranging for the purchase of two houses, to which Clark added another 100 acres to guard against future development. A charter for the Institute was drawn up and signed on March 14, 1950—a scant six months after Sterling and Francine's initial dinner with President Baxter.

Around the same time, with the unhappy news that the Ritz-Carlton was about to be demolished, the Clarks searched for a residence suitable for the display of their collection. They decided to purchase a duplex at 740 Park Avenue. With high ceilings and spacious rooms, the new space offered an opportunity to experiment with ways in which to display the collection. A contemporary inventory indicates that the walls were hung quite densely, even without the Italian, Dutch, and Flemish Old Masters, some of which were stored at Knoedler's.

Clark's desire for a modestly scaled, classical building with natural light for his museum was addressed by the Long Island–based architect Daniel Perry, who had been introduced to the Clarks by their old friend Peter Guille. In August 1953 the Clarks participated in a simple cornerstone-laying ceremony

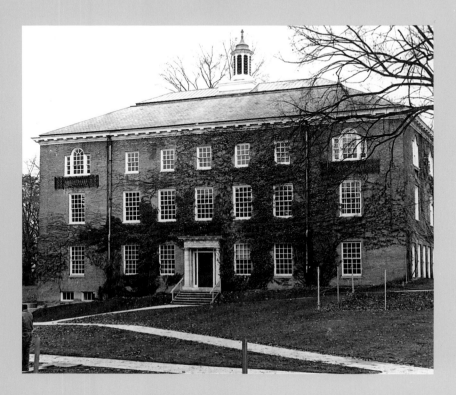

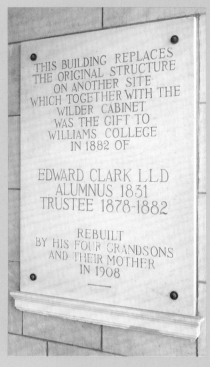

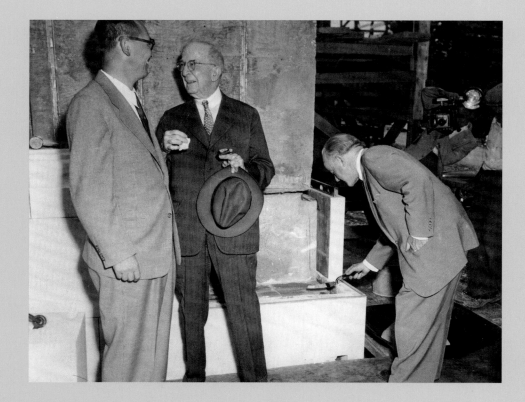

Fig. 3
Cornerstone-laying
ceremony with architect
Daniel Perry (*left*) and
Sterling Clark (*center*), 1953

(fig. 3). The following words were inscribed on the trowel that Sterling used to
lay the foundations of the museum:

> *Within these walls is to be housed beauty which has already stood the test*
> *of time and which will far outlast the tumult of today. In this place men*
> *and women will be strengthened and ennobled by their contact with the*
> *beauty of the ages.*

Installing the collection in the months before and after the May 1955
opening of the museum, Clark saw all his works of art in one place for the first
time. Arranged within the domestically scaled spaces detailed by Schültz and
Leclerc (the same firm that had refurbished Clark's Paris home more than forty
years before), the new museum bore witness to Clark's early passion for Old
Masters, his lifelong commitment to the French Impressionists, and his love
for the work of nineteenth- and twentieth-century American artists like Homer
and Sargent. In the beginning, however, Clark held back the breadth of the col-
lection, choosing to open only one gallery of the museum with an exhibition

of thirty-five paintings, small sculptures, and decorative arts. The inaugural 1955 display was weighted toward a mixture of American artists and French academic paintings (fig. 4), with only one of the Clarks' thirty-eight Renoirs on view. It was a calculated move by Sterling, who not only championed the overlooked academics but also enjoyed flouting the establishment. While overseeing the installation, he wrote, "I expect the critics will give me the works! But I also expect I shall be amused." It was not until the following summer that the largest gallery displaying the Clarks' exceptional collection of Impressionist works was open to the public. The slow unveiling continued throughout the first years of the museum, as each year new galleries were opened, revealing new aspects of the collection to the public.

Fig. 4
Inaugural exhibition,
May 1955

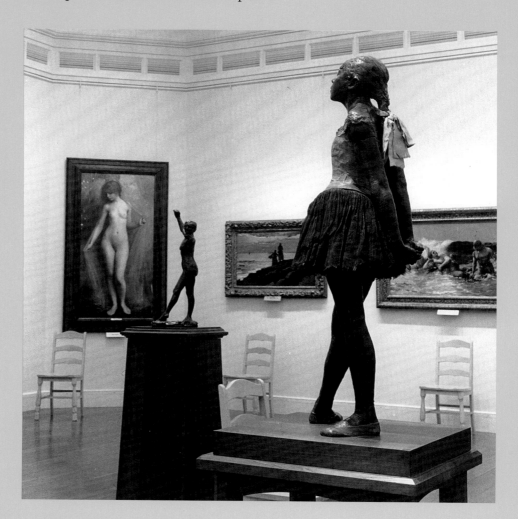

While the Clarks' original holdings remain at the core of the Institute, the collection has changed as it has grown over the years. Sterling died in December 1956, the year after the museum opened, and Francine died in April 1960. Unlike many other collectors who established museums, the Clarks did not place restrictive covenants on the installation of their works or on loans from the collection, giving future generations the ability to develop the institution and to grow programmatically as resources and ambition allowed. A range of acquisitions over the years have upheld the high standards established by the Clarks, the first of which was Ugolino di Nerio's early-fourteenth-century polyptych *Virgin and Child with Saints* (see cat. 24), a bold departure that reflects an early goal of expanding the subject matter, period, and scale of the core collection by seeking out works of unparalleled quality and significance. Jean-Honoré Fragonard's *The Warrior* (see cat. 34), an iconic "fantasy" portrait that has become the centerpiece of the eighteenth-century collection, followed that acquisition.

Intimacy of subject matter and experience—values so important to the Institute's founders—came to guide the Clark's curators and directors in the years that followed, albeit with occasional surprises like the 1997 purchase of a grand piano and pair of stools designed by Sir Lawrence Alma-Tadema (see cat. 96). The collection has also moved to entirely new areas. In 1998 the Clark began to form a collection of European and American nineteenth-century photography, which now includes important works by William Henry Fox Talbot, Gustave Le Gray, Édouard Baldus, Julia Margaret Cameron, Roger Fenton, and Carleton Watkins. Though beyond the Clarks' personal collecting interests, the photography acquisitions have added depth to the Institute's nineteenth-century holdings while following in the aesthetic spirit and commitment to quality that guided the founders' own acquisitions (fig. 5).

The Clark has also received many important gifts and bequests over the years. Early American furniture, formerly in the George A. Cluett collection, now forms the core of the Clark's American decorative arts collection, which includes early American blown and molded glass comprising the Albert and June Lauzon collection as well as exceptional holdings of American silver that were given by Morris and Elizabeth Burrows. In June 2007 the Clark announced the largest gift since the founding of the Institute—a collection of more than two hundred works by foremost late-eighteenth- and early

Fig. 5
Graduate students investigate early photographs in the Manton Study Center for Works on Paper

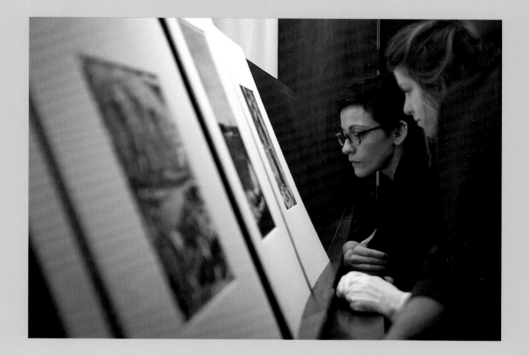

nineteenth-century British artists, including Thomas Gainsborough, J. M. W. Turner, and John Constable. The Institute renamed its 1973 building the Sir Edwin and Lady Manton Research Center in honor of Sir Edwin A. G. Manton (1909–2005), whose family gave that collection to the Clark along with a generous endowment from his foundation.

Situated on a 140-acre campus of lawns, meadows, and wooded trails in the Berkshires of western Massachusetts, the "Clark experience" centers as much on the outdoors as on the indoors, with breathtaking views of the surrounding landscape visible through the large windows of the galleries. True to the intentions of its founders, the Clark fosters individual contemplation and the enjoyment of art in a setting of profound natural beauty (fig. 6), awakening visitors to the importance of art to the human condition. As part of the Clark's commitment to making scholarship and works of art more accessible to public audiences, the Institute oversees a regular program of temporary exhibitions, engaging the expertise of foremost scholars to give viewers an intimate and thought-provoking experience with great works of art (fig. 7). Since 2008, when the Clark opened a new building designed by Tadao Ando, exhibitions have included twentieth-century, contemporary, and non-Western art.

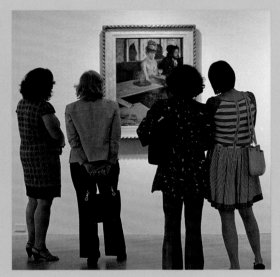

Public access to scholarship and aesthetic experiences energize a rich array of educational programs. Each year, some 25,000 visitors participate in the Clark's educational programming (fig. 8), including thousands of local schoolchildren who come to the Clark through a program that provides free transportation to any school that can visit Williamstown within a day. The Clark further engages younger visitors through Kidspace, an educational collaboration with the Massachusetts Museum of Contemporary Art and the Williams College Museum of Art. Since 2000, the participating institutions have presented exhibitions that put art into education—inspiring teachers to explore multiple approaches to using art across the curriculum. The Clark also collaborates with the Berkshire County Juvenile Court in the Responding to Art Involves Self Expression (RAISE) program. RAISE provides an alternative sentencing model that shifts the paradigm from education to enhancement, offering a new way in which local teens can think about their lives and their potential. Since its inception in 2006, nearly 120 teens have taken part in group meetings, writing and self-awareness exercises, and gallery talks. Complementing those art-focused programs are a broad range of public programs, ranging from concerts (fig. 9) and family activities to films and talks—programs that engage visitors in innovative and meaningful ways.

The public education programs are enhanced by the Center for Education in the Visual Arts (CEVA), which focuses on an interactive approach to gallery

Fig. 6
Williams College students enjoy a hike to the top of Stone Hill at the Clark

Fig. 7
Visitors enjoy the special exhibition *Picasso Looks at Degas*, 2010

Fig. 8
Michael Cassin, director
of the Clark's Center for
Education in the Visual
Arts, helping school chil-
dren engage with Degas's
Little Dancer Aged Fourteen
(see cat. 65)

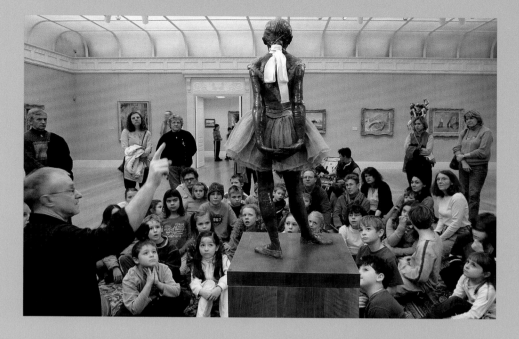

engagement that is flexible enough to respond to the requirements of various
audiences while stimulating cultural, social, and historical awareness and
offering a richer, more personal experience for museum visitors. CEVA not only
trains docents and educational staff at the Clark but also offers courses and col-
loquia around the country and abroad, sharing the Clark's gallery engagement
philosophy with educators beyond the Northeast.

Fig. 9
A summer concert at
the Clark

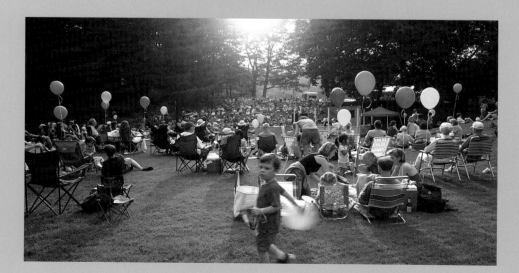

Being Human

The human face and body may represent physical or spiritual beauty, encourage religious devotion, express personality in a portrait, or enact the drama of a narrative. Perhaps no other subject has the potential for such wide-ranging expressive possibilities. Since the Renaissance, painters and sculptors have investigated the human figure from every angle and in every conceivable pose. With the establishment of the first art academies in the seventeenth century, drawing from plaster casts and live models became a central element of artistic training. Faces and figures appear in almost every medium in the collection of the Clark: tempera or oil paintings; silver or porcelain; and prints, drawings, or photographs. These works explore and reflect the lives, interests, and activities of human beings from the fourteenth to the twentieth century.

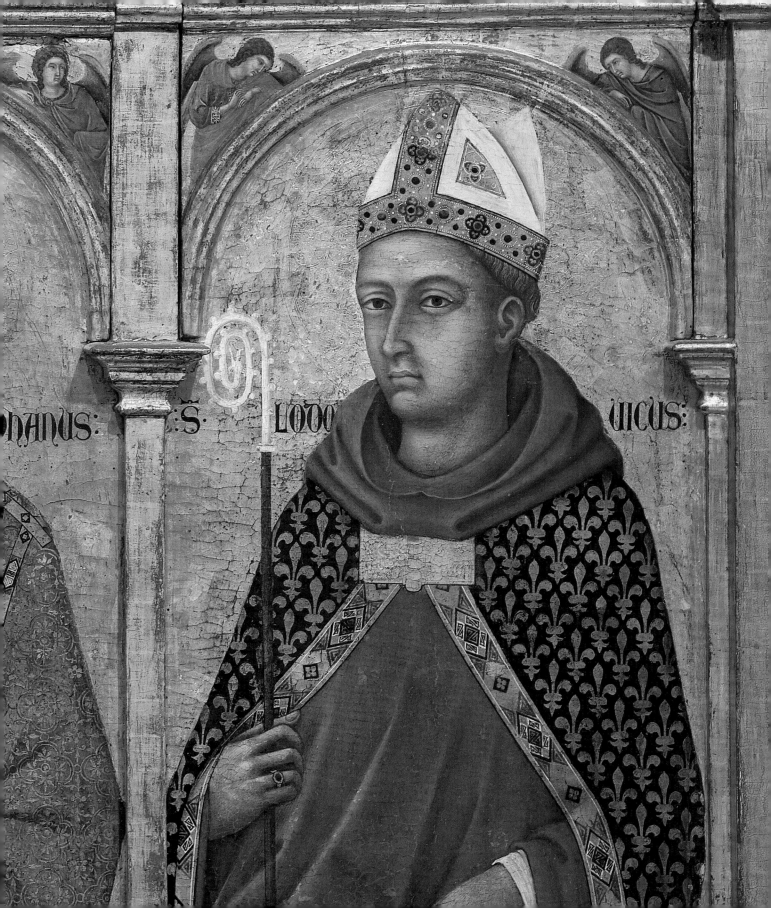

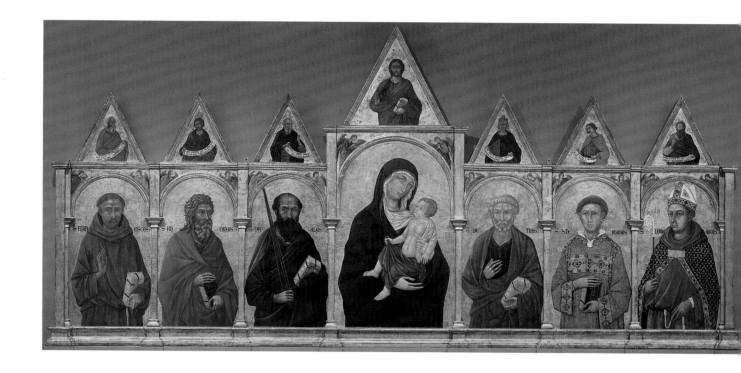

24. **Ugolino di Nerio** (Italian, active c. 1317–1339/49)
Virgin and Child with Saints Francis, Andrew, Paul, Peter, Stephen, and Louis of Toulouse, c. 1317–21
Tempera and gold on panel, 64⁷⁄₁₆ × 137⁷⁄₁₆ in.
(163.7 × 341.4 cm)
Acquired by the Clark, 1962, 1962.148

The figures in Ugolino di Nerio's altarpiece—Jesus and his mother surrounded by saints, angels, and Hebrew prophets—appear against a background of gold leaf that must have shimmered in the reflected candlelight of a fourteenth-century church. They are not presented as actors in a narrative and there is little attempt to create an illusion of real space or three-dimensionality. Instead the figures appear as silent witnesses to the possibility of attaining eternal peace in paradise. Mary and Jesus are proportionally larger than the other figures and they occupy the most prominent position in the center of the altarpiece. Mary wears her traditional ultramarine cloak—the blue pigment of the paint derives from the expensive semiprecious stone lapis lazuli. Other characters are also identified by their costumes and attributes: for example, the saints on the outer panels are Francis of Assisi (on the left) and Louis of Toulouse (on the right), both of whom wear brown Franciscan robes. In addition, Saint Louis wears a cloak patterned with fleurs-de-lis, a symbol that proclaims his French royal lineage, while his miter and staff indicate his status as a Catholic bishop. The altarpiece was probably painted for a Franciscan establishment, sometime after 1317, the year in which Louis was canonized. Though Ugolino came from Siena, where he learned the formal practices of his great predecessor Duccio, recent research suggests that this altarpiece may have been made for a church in Florence.

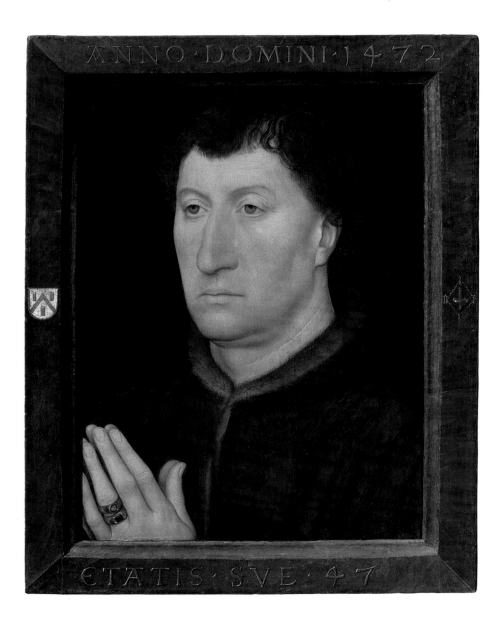

25. **Hans Memling** (South Netherlandish, 1430/40–1494)
The Canon Gilles Joye, 1472
Tempera with oil on panel in original painted frame
14 13/16 × 11 7/16 in. (37.6 × 29.1 cm)
Acquired by Sterling and Francine Clark, 1919, 1955.943

Hans Memling's portrait may have been the right-hand panel of a diptych that included an image of the Virgin and Child on the left, toward which the sitter, Canon Gilles Joye, directed his attention. Joye's solemn expression and the textures of flesh and fur have been painted with minute precision. During the mid-1400s, Joye was a clergyman and a composer of secular and ecclesiastical music in Flanders and Burgundy. The inscriptions on the frame indicate that the work was painted in 1472 when the canon was forty-seven years old. Joye's family crest also appears on the frame and on one of his rings. The sitter's identity was rediscovered in 1960, when a faded label on the back of the panel was viewed in ultraviolet light. Subsequent research revealed that Joye was not always as pious as he appears here; church authorities occasionally reprimanded him for his less than sober lifestyle. The painting suggests, however, that Joye preferred to be remembered for his religious devotion rather than for his worldly pastimes.

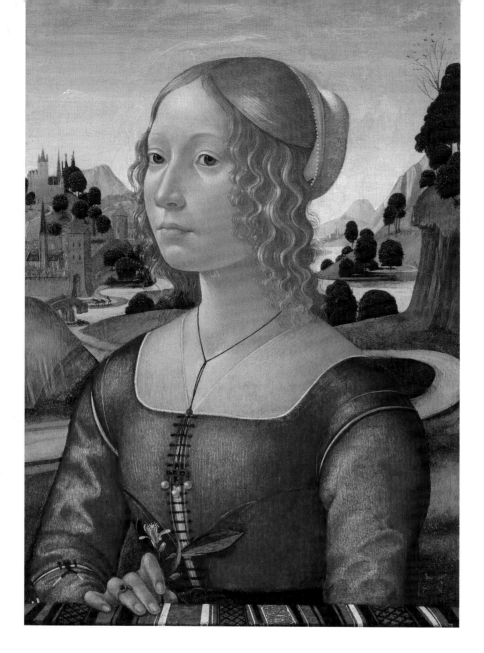

26. **Domenico Ghirlandaio** (Italian, 1449–1494)
Portrait of a Lady, c. 1490
Tempera and oil on panel, 22¹/₁₆ × 14¹³/₁₆ in. (56.1 × 37.7 cm)
Acquired by Sterling Clark, 1913, 1955.938

Trading links between northern and southern Europe in the fifteenth century encouraged the spread of artistic influences in both directions. Paintings like Domenico Ghirlandaio's *Portrait of a Lady*—with its delicate lines, suggestion of three-dimensional form, and landscape background—demonstrate an awareness of Netherlandish portraiture that in turn influenced the work of later Italian artists, including Leonardo and Raphael. Though the sitter has never been reliably identified, the painting was almost certainly made at the time of her wedding, as the sprig of orange blossom she holds is a common marriage symbol. Her youthful beauty would have been seen as a reflection of her virtuous character. Sometime later, other details were added to transform the portrait into an image of Saint Catherine of Alexandria. Those additions were removed before Sterling Clark acquired the painting; however, traces of a halo can still be seen in the sky.

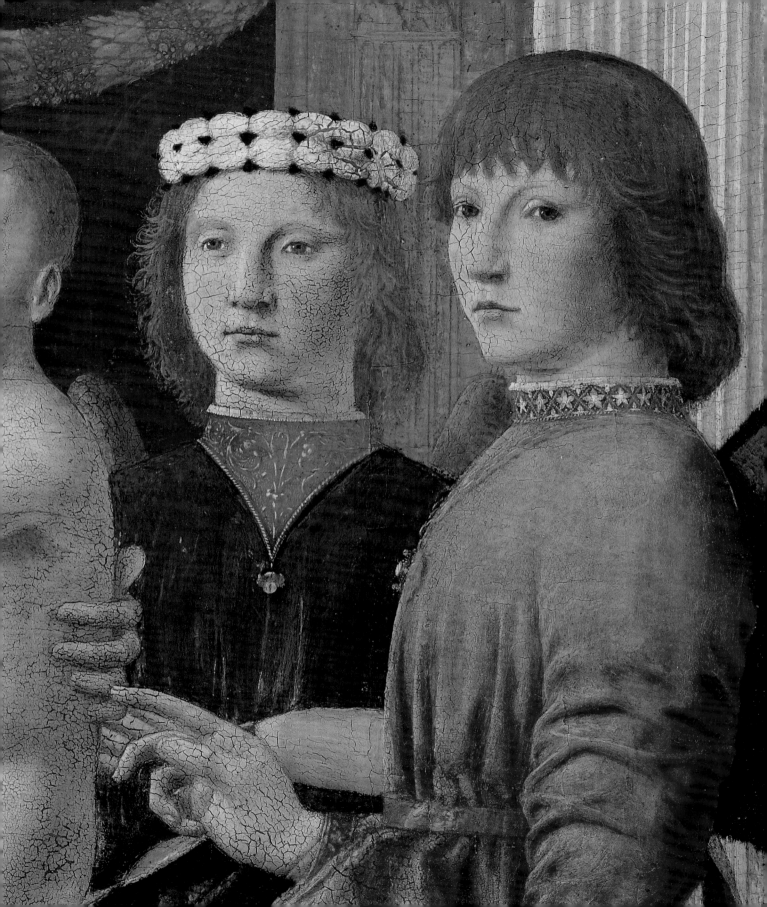

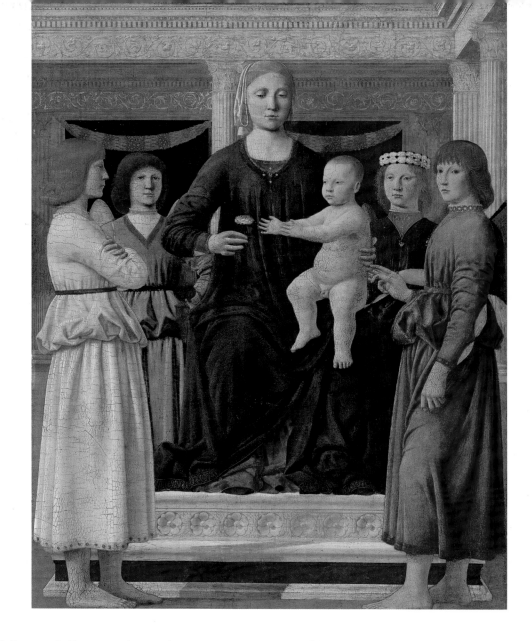

27. Piero della Francesca (Italian, c. 1415/20–1492)
Virgin and Child Enthroned with Four Angels, c. 1460–70
Oil possibly with some tempera on panel, transferred to fabric
on panel, 42⁷/₁₆ × 30⁷/₈ in. (107.8 × 78.4 cm)
Acquired by Sterling Clark, 1914, 1955.948

The figures in Piero della Francesca's painting are positioned
in a coherent corner space defined with fluted columns and
other classical architectural features. Four angels surround
Mary's throne. They resemble caryatids carved from marble,
with wings of various subtle colors half-hidden behind them.
The angel in red points toward Mary and Jesus, who also seem
as solid as carved stone. The painting was probably made for a
specific location, perhaps for a private chapel with a window
on the left through which real light could enter, matching the
painted light and the shadow cast by the angel in white. Jesus
reaches for the flower held by his mother, an action that may
symbolize Christ's acceptance of his Passion and Crucifixion,
or it could mean something quite different. The message of the
painting would have been clear to Piero's patrons, but we may
never know exactly how to interpret it. Like other Renaissance
works, Piero's intelligently beautiful painting combines a
Christian subject with forms derived from the classical past.

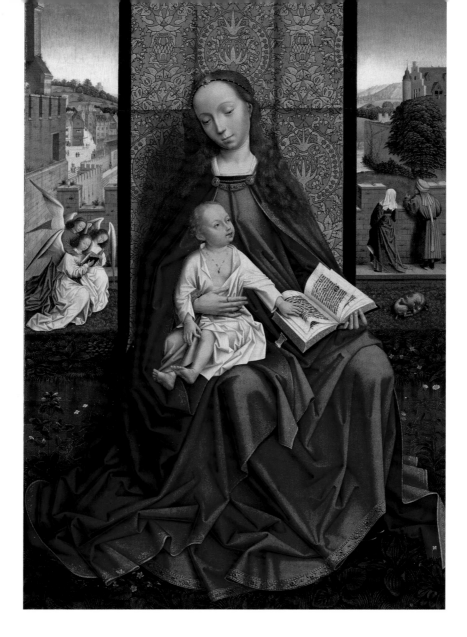

28. **Master of the Embroidered Foliage** (South Netherlandish, active c. 1495–1500)
The Virgin and Child Enthroned, c. 1500
Oil on panel, 38 11/16 × 25 15/16 in. (98.3 × 65.9 cm)
Gift of the Executors of Governor Lehman's Estate and the Edith and Herbert Lehman Foundation, 1968, 1968.299

Medieval altarpieces rarely survived intact; their panels often were dispersed when they were moved from their original locations. This painting may have been the central panel of a triptych. It includes visual symbols that communicate religious messages, some of which are very complex. For example, Mary sits in a walled garden *(hortus conclusus)*, a metaphor for the Christian belief in her continuing virginity. Mary and Jesus appear in the same poses in four other known paintings ascribed to an anonymous "Master of the Embroidered Foliage" by the German art historian Max Friedländer in the twentieth century. A single artist whose name has been lost may have made the paintings, but medieval workshops were like modern architectural practices in which several different individuals worked together in collaboration. The Clark's panel and the other four images may have been painted by a number of artists working from the same full-sized drawing.

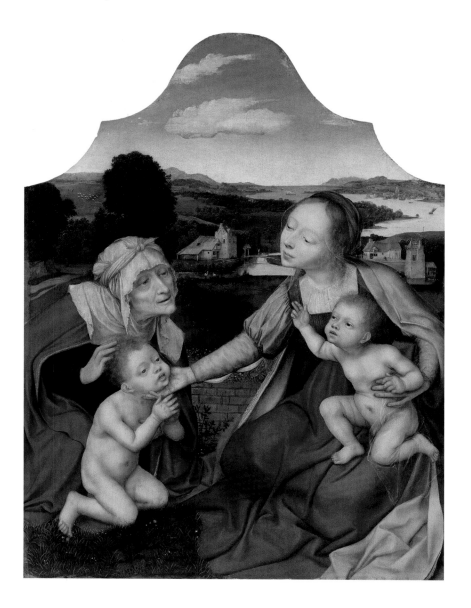

29. Quinten Massys (South Netherlandish, 1466–1530)
Virgin and Child with Saints Elizabeth and John the Baptist,
c. 1520–25
Oil on panel, 24 13/16 × 19 in. (63 × 48.2 cm)
Acquired by the Clark, 1998, 1998.45

Near the beginning of Saint Luke's Gospel the pregnant Virgin Mary visited her elderly cousin Elizabeth, who, miraculously, was also with child. Elizabeth greeted Mary with the words: "Blessed art thou among women, and blessed is the fruit of thy womb." This painting depicts a non-scriptural story that mirrors some of the details of the Gospel narrative. Elizabeth and her son Saint John the Baptist are visiting Mary and

Jesus. Elizabeth and Mary hold John's head at an unnatural angle that surely prefigures his martyrdom by decapitation, while Jesus raises his hand in a blessing. Other details refer to Christ's past and future: shepherds on the hillside hint at the story of his birth and the tiny cross-shaped mast and beam of a distant sailboat on the right are a reminder of the Crucifixion. The painting was probably made in Antwerp in the 1520s. Its curved top suggests that it may have been the central panel of a triptych designed for personal prayer. Massys may or may not have visited Italy, but he was aware of Italian Renaissance art—the head of Saint Elizabeth is almost certainly based on a drawing by Leonardo da Vinci.

30. **Peter Paul Rubens** (Flemish, 1577–1640)
Portrait of Thomas Howard, Earl of Arundel, c. 1629–30
Brush and brown ink, dark brown oil color, and brown and
gray wash heightened with white and touches of red wash on
paper, 18¼ × 14 in. (46.4 × 35.6 cm)
Acquired by Sterling and Francine Clark, 1926, 1955.991

Peter Paul Rubens made this spirited wash drawing as a
study for his finished oil portrait of Thomas Howard, Earl
of Arundel, now in the Isabella Stewart Gardner Museum in
Boston. The sketch contains all of the main elements of the
finished painting, including the earl's confident pose, polished
armor, curling beard and mustache, and look of thoughtful
intelligence in his eyes. Howard was a discerning connoisseur
who acquired a considerable collection of paintings, drawings,
prints, and antique sculpture. He originally met Rubens in
Europe, and they met again when Philip IV of Spain sent the
painter to London as a diplomatic envoy. Both Rubens and
Howard were cultured diplomats and collectors. This splendid
drawing reflects not only the earl's self-assurance but also the
artist's virtuoso skill.

31. Théodore Géricault (French, 1791–1824)
Trumpeter of the Hussars, c. 1815–20
Oil on canvas, 37¹³⁄₁₆ × 28¼ in. (96 × 71.8 cm)
Acquired by Sterling Clark, 1912, 1955.959

Théodore Géricault's earliest paintings of hussars and other cavalry officers were made before the Napoleonic army suffered any major setbacks. The images are full of the exuberant energy and vigorous brushwork that are defining characteristics of Géricault's style. *Trumpeter of the Hussars* was painted later, probably after Napoleon's defeat at Waterloo, and though the technique is similar to Géricault's earlier paintings, the mood is quite different. The soldier and his mount occupy a patch of high ground from which a military engagement can be observed indistinctly through billowing clouds of smoke. The trumpeter's face is in shadow, his expression difficult to read. His right hand rests on his thigh, ready to grasp the bugle hanging from his shoulder to signal a charge or—as the somber tone of the painting suggests—a retreat. The horse stands immobile amidst the cacophony of battle. Géricault captured perfectly the sense of tension that both horse and rider must have felt in such stressful circumstances.

32. Thomas Gainsborough (English, 1727–1788)
Elizabeth and Thomas Linley, c. 1768
Oil on canvas, 27½ × 24½ in. (69.8 × 62.3 cm)
Acquired by Sterling and Francine Clark, 1943, 1955.955

Thomas Gainsborough painted portraits of various individuals in his native Suffolk as well as prominent members of high society in fashionable Bath and, later, London. The Linleys were celebrated musical performers in both Bath and London, and Gainsborough's portrait captures their youthful vivacity.

Famous for her beauty and voice, Elizabeth attracted many suitors before she eloped with Richard Brinsley Sheridan. Her brother Thomas studied the violin in Italy, where he played duets with another prodigy of the age, Wolfgang Amadeus Mozart. This portrait was probably painted just before Thomas's departure for Italy, and it may have been left unfinished. Alternatively, the lack of definition around the edges may have been intended to emphasize the sitters' faces, or perhaps the canvas was a study for a larger painting.

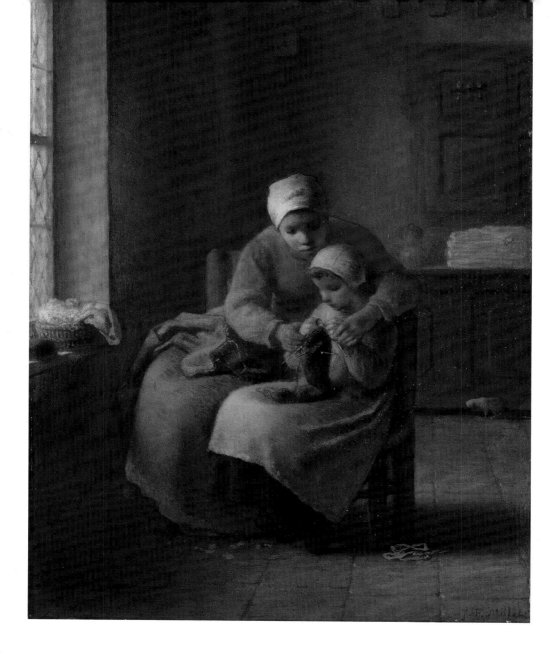

33. **Jean-François Millet** (French, 1814–1875)
The Knitting Lesson, c. 1860
Oil on panel, 16⁵⁄₁₆ × 12⁵⁄₈ in. (41.5 x 32 cm)
Acquired by Sterling and Francine Clark, 1945, 1955.533

The artists who settled in the village of Barbizon, outside Paris, were interested in the unspoiled rural landscape and the lives of the local agricultural workers and their families. In Jean-François Millet's tender painting, a little girl knitting in the round on several needles is helped by an older, more experienced woman who embraces the child as she lends assistance. The figures are not professional models posed in rustic fancy dress, but real country folk involved in the quiet drama of country life. The soft light of the interior enhances the solidity of the broadly painted figures, as if their bodies were carved from a single block of stone. Reactions to Millet's paintings were mixed. Some viewers saw a religious or spiritual dimension in his work. Others felt his sowers, gleaners, spinners, and shepherds were inappropriate subjects for "Art." Fortunately, some collectors recognized the sensitivity with which he portrayed the rural poor—a genuine sentiment that rarely lapsed into sentimentality.

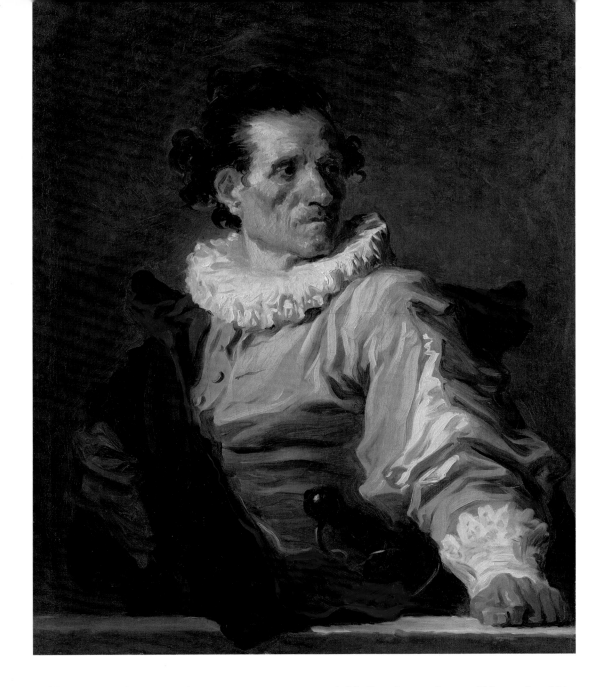

34. **Jean-Honoré Fragonard** (French, 1732–1806)
The Warrior, c. 1770
Oil on canvas, 32 1/16 × 25 3/8 in. (81.5 × 64.5 cm)
Acquired by the Clark, 1964, 1964.8

This is one of a number of so-called fantasy portraits that Jean-Honoré Fragonard painted toward the end of the 1760s. The luscious, creamy handling of the paint suggests that it was probably done in one session. The man's flushed red face and tight lips, the prominence of his sword, and his somewhat bellicose pose—leaning back with his cape thrown over his shoulder—may explain the title by which the painting is now known. He certainly seems like the type who would draw his sword at a moment's notice should he feel the slightest insult; however, his costume is more theatrical than military and his body language is more swagger than real aggression. He seems to be acting out a particular personality type, perhaps a character similar to one found in a play by Molière.

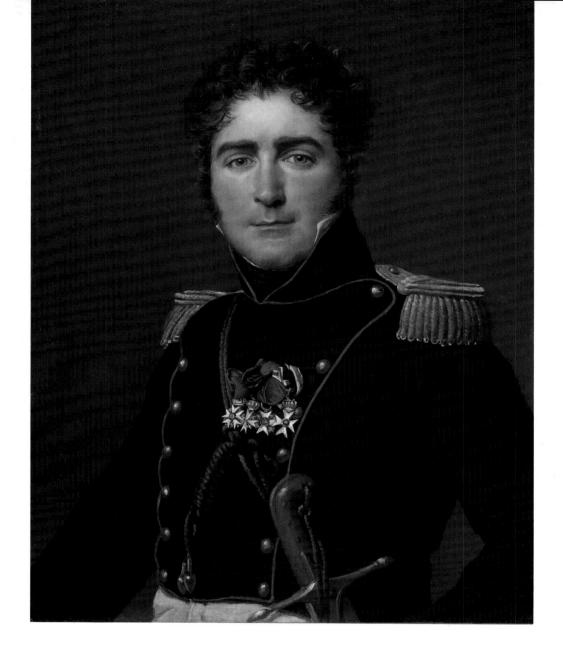

35. **Jacques-Louis David** (French, 1748–1825)
Comte Henri-Amédée-Mercure de Turenne-d'Aynac, 1816
Oil on canvas, 28¼ × 22⅛ in. (71.8 × 56.2 cm)
Acquired by the Clark, 1999, 1999.2

Jacques-Louis David was the artist most closely associated with the court of Napoleon. After the emperor fell from power in 1815, David was exiled to Brussels, where he painted portraits of several other French expatriates, including two of the Comte de Turenne. One of the works, now in the Ny Carlsberg Glyptotek in Copenhagen, shows the count wearing civilian clothes; in the Clark's portrait, he wears a military uniform on which his medals are proudly displayed. The oil paint was applied with considerable finesse, and few traces of the artist's brush are visible, except in the sitter's thickly curling hair. The count's sword was added after the other details—the red piping of his tunic has begun to show through its handle. Perhaps David's portraits were intended to record two aspects of the count's life: his civilian present in the Copenhagen picture and, in the case of the Clark's canvas, his military past—an image that may have seemed incomplete without his sword.

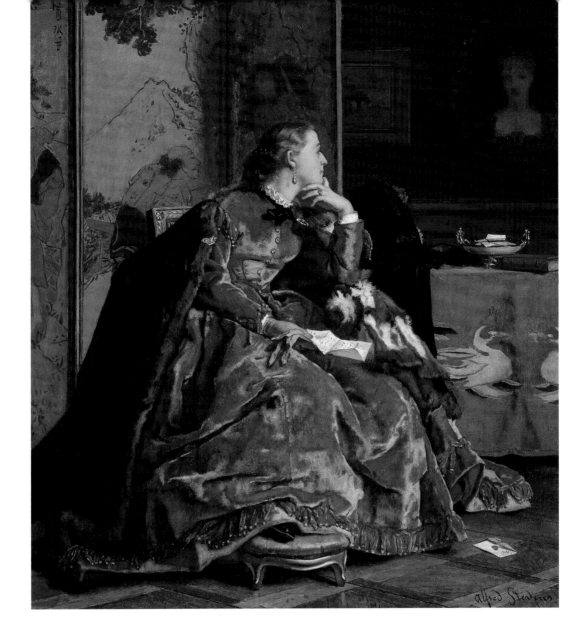

36. **Alfred Stevens** (Belgian, 1823–1906)
A Duchess (The Blue Dress), c. 1866
Oil on panel, 12⅜ × 10¼ in. (31.4 × 26 cm)
Acquired by Sterling and Francine Clark, 1920, 1955.865

Alfred Stevens's exquisitely painted panel offers clues that seem to illustrate a narrative, and yet that narrative remains ambiguous. The young woman in the softly textured blue velvet dress and fur cape apparently has returned from an outing to find a letter. She has opened it with some eagerness, as the envelope lies discarded on the parquet floor. Whatever message the note contains has prompted her to gaze thoughtfully at the portrait on the wall. Several details—the Japanese tablecloth and screen, the woman's jewelry and costume, the pictures in the apartment, and the cards in the dish—suggest that the woman is wealthy and sociable. The balding male figure on the screen, whose profile echoes the woman's, seems to introduce a playful or ironic note to a scene of conspicuous comfort. And how should we understand the title *The Duchess*—is it another touch of irony? Images like this one relate to the genre of seventeenth-century Dutch moralizing scenes; however, while those earlier works usually convey a clear message, Stevens's painting leaves us wondering.

37. **James Tissot** (French, 1836–1902)
Chrysanthemums, c. 1874–76
Oil on canvas, 46⅝ × 30 in. (118.4 × 76.2 cm)
Acquired in honor of David S. Brooke (Institute Director, 1977–94), 1994, 1994.2

James Tissot moved from France to the fashionable North London suburb of St. John's Wood in the early 1870s. There he added a conservatory to his house, which he sometimes used as an informal studio—the metal framework of the conservatory windows can be seen in the top left-hand corner of *Chrysanthemums*. A profusion of blooming flowers fills most of the canvas with a riot of glorious and subtly varied colors: ivory white, lemon yellow, vibrant red-gold, and delicate lavender pink. The painting clearly celebrates the beauty of the abundant flowers, but chrysanthemums were sometimes also used as symbols of death; in the lower half of the picture, a young woman stoops to trim off a few dead leaves, a reminder that beauty fades with time. Like many artists in the second half of the nineteenth century, Tissot was interested in photography. The woman's face—blurred slightly, as it would appear if she had moved while being photographed—may reflect that interest. The shallow space of the composition may relate to the artist's knowledge of Japanese woodblock prints.

38. John Singer Sargent (American, 1856–1925)
Carolus-Duran, 1879
Oil on canvas, 46 × 37¹³⁄₁₆ in. (116.8 × 96 cm)
Acquired by Sterling and Francine Clark, 1920, 1955.14

Sargent studied painting in Paris in his late teens and early twenties, working in the studio of the celebrated portraitist Carolus-Duran. Unlike teachers at the École des beaux-arts, who stressed the practice of drawing in line and tone, Carolus-Duran emphasized the importance of handling the substance of paint in a confident manner. He must have been a very sympathetic teacher for a student of Sargent's ability and natural inclinations. This portrait shows the technical skill and vivacious touch that are distinguishing characteristics of Sargent's later work. In the inscription at the top of the canvas Sargent describes himself as Carolus-Duran's "affectionate pupil." The portrait shows the sitter looking every inch a society figure, with his dandified hair, beautifully combed beard and mustache, elegant cuffs and necktie, and the striking red pin of the French Legion of Honor on the flat brown lapel of his jacket.

39. **Henri de Toulouse-Lautrec** (French, 1864–1901)
Jane Avril, c. 1891–92
Oil on laminate cardboard, mounted on panel, 24⅞ × 16⅝ in.
(63.2 × 42.2 cm)
Acquired by Sterling and Francine Clark, 1940, 1955.566

Jane Avril was one of the most celebrated cabaret performers in France at the end of the nineteenth century. Henri de Toulouse-Lautrec captured her unique style of dancing in images that—like the can-can, the music of Offenbach, and dancehalls such as the Moulin Rouge and the Folies Bergères—have become indelibly associated with fin-de-siècle Paris and the nightlife of Montmartre. Although in this portrait the dancer is dressed for Parisian boulevards in a high-collared cape and a somewhat elaborate hat, the artist shows her yellow face, orange hair, and red lips as they might have looked in the unnatural glare of stage lighting.

40. **Paul Gauguin** (French, 1848–1903)
Young Christian Girl, 1894
Oil on canvas, 25¹¹⁄₁₆ × 18³⁄₈ in. (65.3 × 46.7 cm)
Acquired by the Clark in honor of Harding F. Bancroft (Institute Trustee, 1970–87; President, 1977–87), 1986, 1986.22

Paul Gauguin returned to Europe in 1893 after his first visit to the South Seas in search of a way of life radically different from the one he had in France. He visited Belgium and Paris before settling for some months in Brittany, where he painted this remarkable image of a young girl in a colorful Breton landscape. The girl's lowered eyes and hands joined in prayer are reminiscent of fifteenth-century Flemish devotional portraits (see cat. 25). She wears a cross around her neck and a bright yellow dress instead of the traditional black-and-white Breton costume. Christian missionaries gave islanders in the South Seas similar dresses to cover their nakedness. Indefinite lilac shapes resembling angel's wings fan out from the girl's shoulders. Perhaps the sincerity of the young girl's prayer has endowed her with a kind of transcendent, angelic innocence. Alternatively, Gauguin may have been exploring the purity of color. Arranged in vibrant combinations, flat, colorful shapes complement each other on the surface of the canvas.

41. **Ammi Phillips** (American, 1788–1865)
Portrait of Harriet Campbell, c. 1815
Oil on canvas, 48½ × 25 in. (123.2 × 63.5 cm)
Gift of Oliver Eldridge in memory of Sarah Fairchild Anderson, teacher of art, North Adams Public Schools, daughter of Harriet Campbell, 1991, 1991.8

Ammi Phillips was a largely self-taught painter who traveled around New England and New York State, advertising his skills as a portraitist in newspapers and receiving commissions from prominent citizens. *Portrait of Harriet Campbell* was probably painted sometime around 1815, when the sitter was about seven or eight years old. The little girl's formal pose, high-waisted, tubular dress, pearls, fringed parasol, and prim-looking reticule make her seem older than her years. Phillips frequently repeated details of costume, pose, and coloring in portraits of different subjects. This painting shares similar features with Phillips's portrait of another little girl, coincidentally also named Harriet, now in the Fogg Art Museum at Harvard University. Harriet Campbell's daughter, Sarah Fairchild Anderson, an art teacher in North Adams, Massachusetts, inherited her mother's portrait. It was given to the Clark in Sarah's memory in 1991.

42. Berthe Morisot (French, 1841–1895)
The Bath, 1885–86
Oil on canvas, 36¼ × 28⅞ in. (92.1 × 73.3 cm)
Acquired by Sterling and Francine Clark, 1949, 1955.926

The model for Berthe Morisot's painting was a friend of the artist—seventeen-year-old Isabelle Lambert. The sitter is clearly aware of being observed but she seems completely unselfconscious, even in her loose-fitting underclothes. With her hairbrush on her lap, she raises her arms above her head,

crooking one little finger as she fixes her hair. The pinks of her face and upper body are distinguished from the pinks of the background wall by sinuous contours. Though the painting may seem like a spontaneous sketch, an improvised image that grew as it was being painted, a number of clues make it clear that it evolved during more than one session. Alterations are visible in several places, particularly in the drawing of the young woman's hands. Those changes might account for the appearance of two signatures on the side of the tub to the right of the canvas.

43. Mary Cassatt (American, active in France, 1844–1926)
Woman with Baby, c. 1902
Pastel on gray paper, 28³⁄₈ × 20⁷⁄₈ in. (72.1 × 53 cm)
Gift of the Executors of Governor Lehman's Estate and the
Edith and Herbert Lehman Foundation, 1968, 1968.301

Mary Cassatt moved to Paris in the mid-1860s and studied
with Jean-Léon Gérôme, who was known for his meticulous
draftsmanship and the highly finished detail of his paintings
(see cat. 48). Though Cassatt's work differed from Gérôme's in
subject matter, spirit, and technique, drawing remained an
essential element in her paintings, prints, and pastels. This
pastel of a young woman in an orange kimono embracing a

naked infant is a remarkable synthesis of linear precision and
expressive gesture. The baby's hand against the woman's chest
as well as the lips, limbs, and facial features are clearly defined,
like the lines in one of Cassatt's drypoints or the contours in a
Japanese woodcut. Although the sitters were not in fact parent
and child, the tender, trusting interaction between them
clearly derives from traditional mother-and-child/virgin-and-
child imagery. Cassatt was greatly influenced by the work of
Degas, and she had seen and admired his pastels in 1875. Later,
when her submissions to the Paris Salon were rejected, Degas
invited her to show her work with the Impressionists. She
agreed enthusiastically, exhibiting for the first time at their
fourth group show in 1879.

44. **Pierre-Auguste Renoir** (French, 1841–1919)
Woman with a Fan, c. 1879
Oil on canvas, 25¾ × 21¼ in. (65.4 × 54 cm)
Acquired by Sterling and Francine Clark, 1938, 1955.595

Woman with a Fan is a fascinating and slightly enigmatic image. The young woman holds, rather hesitantly, a Japanese fan in one hand. The painting demonstrates Pierre-Auguste Renoir's awareness of the fashion for such accessories in late-nineteenth-century France. But this fan is more than merely decorative, it is also a very effective compositional device: its shape echoes that of the woman's head and her flower-decorated bonnet. The clearly defined, circular forms contrast with the indefinite shapes of the flowers in the background on the left and the strong vertical lines on the right. Though her mouth curves upward in a half-smile the woman's eyes seem somewhat melancholic.

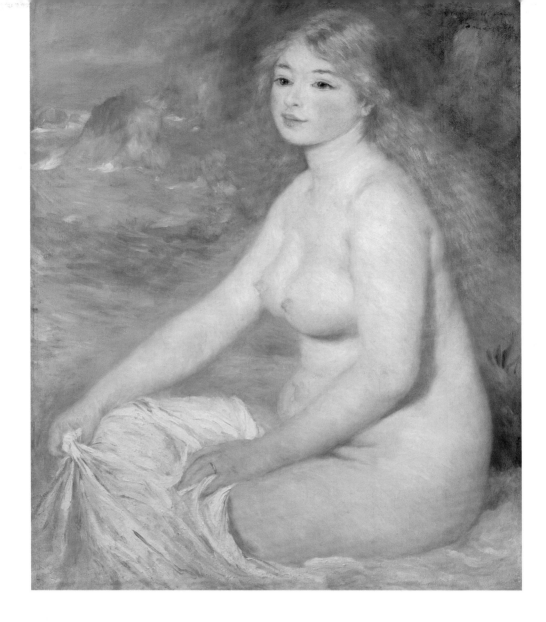

45. Pierre-Auguste Renoir (French, 1841–1919)
Blonde Bather, 1881
Oil on canvas, 32⅛ × 25¾ in. (81.6 × 65.4 cm)
Acquired by Sterling and Francine Clark, 1926, 1955.609

In 1874, the year after Bouguereau's *Nymphs and Satyr* (see cat. 58) was exhibited in Paris, Renoir, Monet, Pissarro, and others held their first group exhibition at the studio of the photographer Nadar. The works on display provoked intense reactions, including the critic Louis Leroy's disparaging reference to Monet's painting *Impression: Sunrise,* which resulted in the members of the group being labeled "Impressionists." By the beginning of the 1880s, Renoir had begun to move away from painting in the Impressionist manner, and he visited Italy to study Renaissance figure paintings and frescoes from Pompeii. There he painted this glorious nude. The model was probably the young Aline Charigot, who would later become Renoir's wife. Though the rocky seascape in the background resembles an Impressionist image, the bather is painted in sharper focus, her creamy skin glowing pink and white in the warm sun, the rounded forms of her body resembling those of a Greek or Roman goddess. Though there are no specific symbols to connect the figure with a classical subject, the association of sensuous femininity and a Mediterranean setting make it almost impossible to resist seeing the bather as a nineteenth-century Venus or Galatea, risen from the sea.

46. **Albrecht Dürer** (German, 1471–1528)
Adam and Eve, 1504
Engraving on paper, 9¾ × 7⁹⁄₁₆ in. (24.8 × 19.2 cm)
Acquired by the Clark, 1968, 1968.56

The story of Adam and Eve was an attractive subject for many fifteenth- and sixteenth-century artists, as it allowed them to draw nude male and female bodies while illustrating a respectable scriptural narrative. In Albrecht Dürer's famous engraving, the two figures stand in front of a dark glade filled with various animals dwelling peacefully together—even a cat and mouse in the foreground. The artist's technical skill is astonishing. The textures of tree bark, silky cat's fur, rippling muscle, and tightly curling hair have been printed from grooves incised into a metal plate with an engraving tool. The figures demonstrate Dürer's knowledge of classical statuary, though their proportions and the delineations of muscle and sinew are more detailed than idealized, more human than divine. Dürer seems to have conflated two episodes of the story into one image. The serpent has just given the fruit to Eve and neither she nor Adam has taken a bite. At that moment they were still without sin and unashamed of their nudity, but—presumably to conform to early sixteenth-century standards of propriety—the artist has covered their genitalia with leaves.

47. **Pablo Picasso** (Spanish, 1881–1973)
The Frugal Repast, 1904
Etching on paper, plate: 18⅛ × 14⅞ in. (46.1 × 37.8 cm);
sheet: 20¹⁵⁄₁₆ × 17⁷⁄₁₆ in. (53.2 × 44.3 cm)
Acquired by the Clark, 1962, 1962.89

At the beginning of the twentieth century, Paris had a unique profile as an art capital. Artists and students flocked there from all over Europe and North America to study in the museums and to benefit from the cultural excitement of the city. When Pablo Picasso moved to Paris from Spain in 1900, he encountered the work of recent and contemporary artists and explored some of the less respectable parts of the city.
He surely must have had in mind Degas's famous painting *The Absinthe Drinker* when he composed *The Frugal Repast*. The print depicts two emaciated figures sitting at a table spread with a cloth but bearing very little food. The light—dim though it is in the seedy interior—reveals their sharp features, bony limbs, and attenuated hands. The figures stare in different directions, as if they have very little to say to each other. The mood of the print is dark and disturbing, a far cry from the dignified poverty of Millet's *Knitting Lesson* (see cat. 33) or the stylish elegance of Lartigue's Paris (see cat. 94).

48. **Jean-Léon Gérôme** (French, 1824–1904)
The Snake Charmer, c. 1879
Oil on canvas, 32³⁄₈ × 47⁵⁄₈ in. (82.2 × 121 cm)
Acquired by Sterling and Francine Clark, 1942, 1955.51

While the Barbizon painters focused their attention on rural France, other artists looked further afield for more exotic subjects. Jean-Léon Gérôme chose themes from the classical past and French history as well as imagery from North Africa and the Near East, so-called Orientalist subjects that would engage and excite the art-buying classes in Paris. The image of a large snake wrapping its scaly body around the smooth flesh of a naked boy while an elderly flute player charms the creature with music—and while several dusty observers stare with almost hypnotized interest—must have sent shivers down a number of spines when the painting was first exhibited. Even in the twenty-first century, the image provokes mixed and complex reactions: admiration, amazement, fascination, embarrassment, and discomfort. Like a historical novelist, Gérôme researched his subjects thoroughly—the staggeringly realistic glazed tiles on the back wall, for example, are based on real tiles from various locations. He then assembled that factual raw material into a work of fiction painted with an attention to detail that enhances the impression of a real event witnessed live.

49. **John Singer Sargent** (American, 1856–1925)
Fumée d'Ambre Gris (Smoke of Ambergris), 1880
Oil on canvas, 54¾ × 35¹¹⁄₁₆ in. (139.1 × 90.6 cm)
Acquired by Sterling Clark, 1914, 1955.15

Fumée d'Ambre Gris is a very different kind of Orientalist image. Fresh from studying in Paris (see cat. 38), John Singer Sargent visited North Africa in 1879–80. This painting is a composite image that combines architecture from one part of North Africa with a costume and jewelry from other locations. The figure stands like a statue in a niche, holding a shawl above her head to catch the aromatic smoke that rises from an incense burner. This may be a religious ritual, or the woman might be preparing herself for a romantic encounter—ambergris was used to make perfume and was thought to have aphrodisiac properties. Though the meaning of the painting may be ambiguous, perhaps deliberately so, the artist's technique is undeniable and extremely accomplished. The image is a magical confection of white, off-white, and cream, accented by touches of red and orange, like a symphony in white by Whistler or a twentieth-century abstraction in which color and paint are themselves the subjects of the work.

A GREENHOUSE FOR IDEAS

The Clark is one of only a handful of institutions that encompass both an art museum and a center for research and higher education in the visual arts. Supported by one of the largest art research libraries in the country, the Institute's Research and Academic Program (RAP) has become a laboratory, or "greenhouse," for ideas that addresses issues in the visual arts through an active program of scholarly publications, resident fellowships for international scholars, conferences (fig. 1), lectures, conversations, and colloquia—held in Williamstown and at other sites around the world—as well as a master's degree program in the history of art that is co-organized with Williams College.

While Sterling Clark did not imagine the breadth and scope of the Clark's Research and Academic Program, he understood that the Institute was to be established in an academic community, and the potential of the Clark's current scholarly and educational engagement was expressed in its 1950 charter, which calls for the Institute "to engage in or assist educational activities, teaching, and research." The early 1960s was a consequential period for shaping the Clark's dual mission. Only five years after Sterling's death, the Institute's trust-ees strengthened the Clark's programmatic ties to Williams College, which was then under the leadership of President John E. (Jack) Sawyer. In 1961 the Robert Sterling Clark Professorship was established at Williams and was funded by the Robert Sterling Clark Foundation (established in New York and separate from the Williamstown institution). The professorship has attracted a number of world-renowned scholars who have assisted the Clark with important acquisi-tions as well as the realization of academic goals. The list of scholars holding Clark professorships in the Institute's first decade is formidable, beginning with the Italian Renaissance scholar and curator John Pope-Hennessy and followed by Ellis Waterhouse, Jacob Rosenberg, Wolfgang Stechow, Sherman Lee, and

Julius Held. In those early years, the Clark also enlisted Egbert Haverkamp-Begemann, a foremost authority on Dutch art, to catalogue the drawings collection—research that was published in 1964.

It was also in the 1960s that the Clark's board of trustees began to discuss a graduate program in the history of art (fig. 2), with the College overseeing the academic program and awarding of degrees. With Sawyer's support, the eminent scholar George Heard Hamilton moved from Yale University to become not only the Clark's director but also the first head of the Williams College Graduate Program in the History of Art. The first class of graduate students arrived in 1972. With its commitment to debate, inquiry, and the highest standards of scholarship, the program has made immeasurable contributions to the rich intellectual life of the Institute. Together with the college's well-known undergraduate program in art history, the graduate program has made

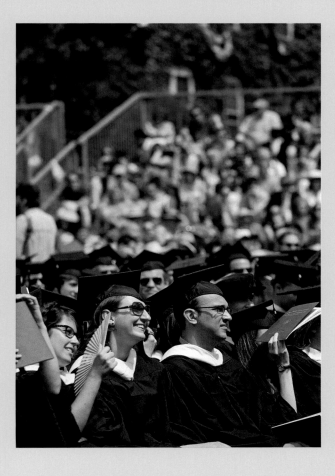

Fig. 1
Previous page, Kavita Singh, New Delhi, consultant for International Programs at the Clark, and Rana Mitter, Oxford, participate in the "Asian Art History in the Twenty-first Century" conference, 2006

Fig. 2
Williams College graduation, 2011

significant contributions to the field over the years, resulting in Williams now being recognized as one of the premier centers for the education of curatorial and academic professionals in the history of art.

To support the plan for a program of graduate study, the Clark's trustees decided to establish an art history research library in 1962. Sterling's own collection of illustrated books and other rare volumes formed the core of the library's initial holdings, and they were soon bolstered by the purchase of the library of the Duveen Brothers art-dealing firm, as well as that of the Dutch art historian W. R. Juynboll. Today the library houses more than 250,000 volumes, including books, bound periodicals, and auction sales catalogues, with several thousand new titles added each year (fig. 3). Under the direction of librarian Michael Rinehart (1966–86), the Clark also raised its scholarly profile as the headquarters of the Répertoire international de la littérature de l'art (RILA), which evolved into the Bibliography of the History of Art (BHA)—a program that became part of the Getty Trust in the 1980s (though it continued to be housed at the Clark until 2000). Unlike most research libraries of its kind, the Clark library is open to the public year-round.

Fig. 3
Graduate students studying in the Clark Art Institute Library

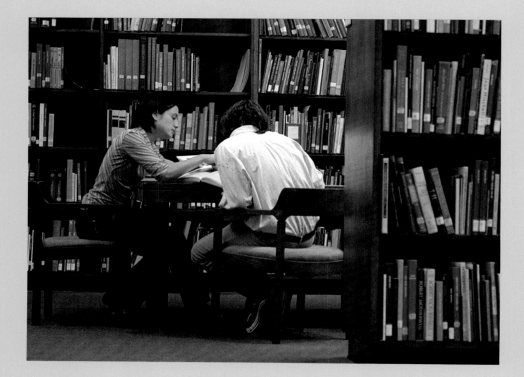

Fig. 6
Clark Studies in the Visual Arts
publication series

Clark Invitational Colloquium, brings a group of ten to fifteen scholars to the Institute to discuss proposed topics of scholarly interest. The discussions occur without formal presentations, allowing for direct and continuous peer-to-peer interactions. As with the symposia, the range of colloquia topics is expansive, addressing issues as disparate as gender studies in the discipline to current scholarship on modern indigenous art.

Curator Roundtables bring together curators and their collaborators who are in the early stages of developing an ambitious exhibition project. Invitees spend two days at the Clark shaping the conceptual and intellectual agenda of an exhibition and its accompanying catalogue. Clark Conversations are perhaps the most intimate of the Institute's academic programs, with leading scholars sharing their personal intellectual histories and commitments to the profession in a relaxed, intimate setting.

Seeking to expand the purview of art-historical inquiry to encompass global issues in the visual arts, the Clark has undertaken a series of special international initiatives in South Africa, Eastern and Central Europe, and Southeast Asia. An ambitious series of programs in partnership with the Andrew W. Mellon Foundation engages with new approaches to the study of the material world as they challenge traditional conceptions of how art history is written, with the goal of illuminating the variety of ways in which the visual

significant contributions to the field over the years, resulting in Williams now being recognized as one of the premier centers for the education of curatorial and academic professionals in the history of art.

To support the plan for a program of graduate study, the Clark's trustees decided to establish an art history research library in 1962. Sterling's own collection of illustrated books and other rare volumes formed the core of the library's initial holdings, and they were soon bolstered by the purchase of the library of the Duveen Brothers art-dealing firm, as well as that of the Dutch art historian W. R. Juynboll. Today the library houses more than 250,000 volumes, including books, bound periodicals, and auction sales catalogues, with several thousand new titles added each year (fig. 3). Under the direction of librarian Michael Rinehart (1966–86), the Clark also raised its scholarly profile as the headquarters of the Répertoire international de la littérature de l'art (RILA), which evolved into the Bibliography of the History of Art (BHA)—a program that became part of the Getty Trust in the 1980s (though it continued to be housed at the Clark until 2000). Unlike most research libraries of its kind, the Clark library is open to the public year-round.

Fig. 3
Graduate students studying in the Clark Art Institute Library

To accommodate the programmatic expansion, Hamilton oversaw the construction of a new building that would house an expansive courtyard lobby, the art history library, an auditorium, classrooms, and additional offices. With a small, future expansion, it would eventually encompass temporary exhibition galleries as well as a shop and café. Now called the Manton Research Center, honoring an extraordinary gift from the estate of Sir Edwin A.G. Manton, the building is also home to the offices, seminar room, and study carrels for the Williams College Graduate Program in the History of Art.

While the Clark's library and graduate program make up the foundation of its two-part mission, in the late 1990s the Research and Academic Program expanded its contribution to the field with a visiting scholars program that has attracted nearly three hundred individuals from a variety of disciplines. The fellowships support in-depth research in the visual arts and related disciplines with scholars who constitute an art-historical "think tank" dedicated to understanding the visual arts (fig. 4).

The Clark also initiated a conference and symposia program that regularly organizes intellectual events in Williamstown and at other sites. Conferences organized by the Institute offer a forum for discussions on the philosophy and practice of art history today (fig. 5), and they address a wide range of subjects

Fig. 4
The Clark visiting scholars' residence

Fig. 5
Clark conference audience

and approaches to the discipline, from "The Two Art Histories" (1999) to emerging methodologies in Asian art (2006) and the relationship of art history to fiction writing (2010). The Institute publishes *Clark Studies in the Visual Arts* (fig. 6) based on the proceedings of those conferences, providing a forum for scholars and museum professionals to document a variety of issues. With fourteen volumes to date, the conference and subsequent publications encourage an interdisciplinary exploration of issues that are timely, relevant, and controversial.

A variety of smaller-scale academic programs are organized each year as well (fig. 7). Clark symposia bring together scholars from a variety of specialties to discuss selected topics before audiences small and large. Symposia titles range from "Gender and the Art Museum" (2000) to "Artistic Crossings of the Black Atlantic" (2008) and "Science, Ethics, and the Transformations of Art in the Thirteenth and Fourteenth Centuries" (2013). Another program format, the

Fig. 6
Clark Studies in the Visual Arts
publication series

Clark Invitational Colloquium, brings a group of ten to fifteen scholars to the Institute to discuss proposed topics of scholarly interest. The discussions occur without formal presentations, allowing for direct and continuous peer-to-peer interactions. As with the symposia, the range of colloquia topics is expansive, addressing issues as disparate as gender studies in the discipline to current scholarship on modern indigenous art.

Curator Roundtables bring together curators and their collaborators who are in the early stages of developing an ambitious exhibition project. Invitees spend two days at the Clark shaping the conceptual and intellectual agenda of an exhibition and its accompanying catalogue. Clark Conversations are perhaps the most intimate of the Institute's academic programs, with leading scholars sharing their personal intellectual histories and commitments to the profession in a relaxed, intimate setting.

Seeking to expand the purview of art-historical inquiry to encompass global issues in the visual arts, the Clark has undertaken a series of special international initiatives in South Africa, Eastern and Central Europe, and Southeast Asia. An ambitious series of programs in partnership with the Andrew W. Mellon Foundation engages with new approaches to the study of the material world as they challenge traditional conceptions of how art history is written, with the goal of illuminating the variety of ways in which the visual

Fig. 7
Abdellah Karroum speaking at the "Contemporary African Art: History, Theory, and Practice" workshop, 2008

Fig. 8
Clark–Institute national d'histoire de l'art workshop, fondation Hartung-Bergman, Antibes, France, 2013

arts are addressed in different regions around the world (see fig. 8). Each year, the Clark also partners with other art-historical research institutes—in recent years, the Getty Research Institute in Los Angeles, the Pulitzer Foundation in St. Louis, and the Institut national d'histoire de l'art in Paris. The Clark has also hosted the College Art Association, the International Association of Research Institutes in the History of Art, the National Committee for the History of Art (the American affiliate of the Comité International d'Histoire de l'Art [CIHA]), and the Council on Library and Information Resources (CLIR).

In articulating its dual mission, the quality of ideas in the Clark's programs has come to matter as much as the quality of the art at the Clark. The Institute's commitment to intellectual engagement and inquiry follows the belief that the humanities are instrumental to a better understanding of and meaningful participation in society at large. Investigation of the visual arts offers deep insight into our culture and that of others, enlarging our view of the world while imparting a sense of shared human identity. With this consciousness, the Research and Academic Program strives to address what is taught, thought, and written in the visual arts. As a point of retreat and convergence for scholars, students, and an interested public, the Clark today is a catalyst for ideas, openness of conversation, and independence and freedom of thought and imagination.

The Mind of the Artist

Works of art are the end product of a series of decisions made by artists and designers, who plan, draw, and shape materials with their imaginations, intellects, and hands. The works here may express ideas and emotions or the circumstances of an artist's personal life or contemporary society. Works of art may also refer to other art, incorporating or expanding on traditional forms from earlier periods of history or rejecting tradition altogether. Artists may be influenced by imagery from other cultures or by new technologies, and they may spend years developing their technical skills and honing their sensitivity. A preparatory drawing hints at an artist's thought process, just as a finished work reveals complex layers of meaning. In the end there is, of course, no formula for making art, no recipe for mixing tradition and innovation, skill and experience, synthesis and imagination, with the right amount of creativity—that touch of the indefinable that makes a lasting masterpiece.

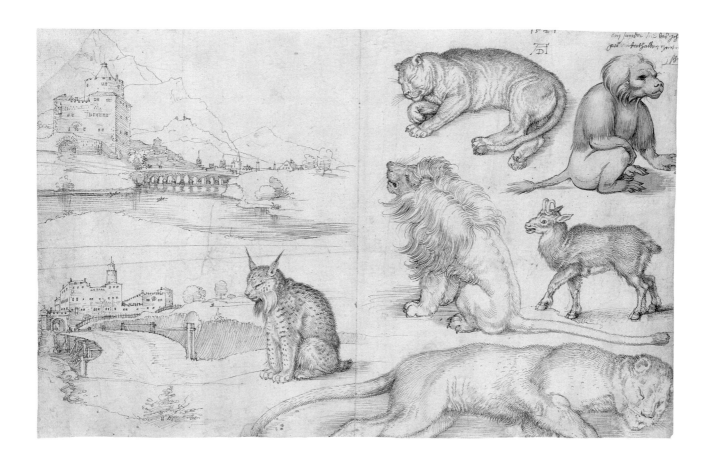

50. **Albrecht Dürer** (German, 1471–1528)
Sketches of Animals and Landscapes, 1521
Pen, black ink, and blue, gray, and rose wash on paper,
10⁷⁄₁₆ × 15⁵⁄₈ in. (26.5 × 39.7 cm)
Acquired by Sterling and Francine Clark, 1919, 1955.1848

Dürer made drawings that not only explore the natural world
but also give visual form to the fantastical products of his
imagination. He spent most of his life in his hometown of
Nuremberg, Germany, but made frequent trips to other parts
of Europe, drawing the interesting sights he encountered along
the way. In 1521 while in Brussels, Dürer visited the zoo where
he drew several of the exotic animals, noting the texture of
a lion's mane, the twist of a lynx's ears, and the strange blue
coloring of an ape. As paper was an expensive, handmade
commodity in the sixteenth century, artists made good use of
every inch. Dürer filled the left-hand portion of this sheet with
two minutely detailed landscape studies that were probably
done on a separate occasion and bear no relation to the animal
sketches.

51. **Claude Lorrain** (French, 1604/5–1682)
A View Outside the Piazza del Popolo in Rome, 1640–41
Black chalk, gray and brown wash, pen, and brown ink framing lines on paper, 8 11/16 × 12 5/8 in. (22 × 32 cm)
Acquired by the Clark, 2007, 2007.5.1

Claude's finished paintings (see cat. 2) are carefully constructed, lyrical evocations of landscape rather than direct transcriptions of nature. His drawings, however, often include topographical details of the countryside around Rome as well as sites within the city. *A View Outside the Piazza del Popolo in Rome* shows a line of buildings and trees, church spires, and a dome, rising above a gently sloping stretch of ground. On the left beyond the rooftops we see a number of poplar trees and a view of a

mountain, which is drawn more faintly to indicate its distance. Claude added extra details—a roof and another group of trees—to the scene on the right in brown ink. This largely horizontal view is drawn across the middle of an inked rectangle, with two bulls—or one bull drawn twice—in the otherwise empty foreground. At first glance the animals look slightly out of place so close to the urban setting, but in the seventeenth century, open spaces within the city were often used for grazing. The Forum itself, just a short distance south of the Piazza del Popolo, was known for some time as the *campo vaccino*, or the "field of cattle." In drawings like this one, Claude recorded the raw material that he used later in his studio to transform nature into art.

52. Giovanni Benedetto Castiglione (Italian, 1609–1664)

Crucifixion with the Virgin, Saints John and Mary Magdalene, and God the Father, c. 1651

Brush and brown oil paint with touches of blue, red, and white on paper, 16³⁄₈ × 11⁷⁄₁₆ in. (41.6 × 29 cm)

Acquired by the Clark, 2003, 2003.9.15

Giovanni Benedetto Castiglione's oil study of the Crucifixion shows the figure of Jesus from the side and below, his body making an angular zigzag shape against the straight lines of the cross. Christ's head has fallen forward onto his chest, and his hair prevents us from seeing his face. Jesus's position is echoed by the pose of God the Father, who hovers in the air behind the cross with arms outstretched, accompanied by angels. The figures at the foot of the cross express their reactions in a variety of ways. The Virgin Mary—identified by the rapidly applied touches of blue in her draperies—is overcome with grief. She leans back to gaze at her son, her upper body supported by Saint John the Evangelist. Mary Magdalene looks up at Christ with one arm raised in a gesture of distress. Castiglione's oil-on-paper studies were intended as independent devotional works, not as sketches for other paintings. This unusual, asymmetrical composition, with its writhing lines, restless brushwork, and low viewpoint, presents the scriptural scene with a powerful emotional intensity, as if the figures on the ground are sharing their anguish with the spectator.

53. **Rembrandt van Rijn** (Dutch, 1606–1669)
Nathan Admonishing David, c. 1652–53
Pen and brown ink on paper, 4¹⁵⁄₁₆ × 5⅞ in. (12.6 × 14.9 cm)
Acquired by the Clark, 2003, 2003.9.29

Though small in scale, this drawing demonstrates Rembrandt's ability to express nuances of emotion with the most economical use of line. God instructed Nathan to rebuke King David for lusting after Bathsheba and for sending her husband Uriah the Hittite to his death in battle. Nathan stands beside the king, his hand raised in reprimand, though he leans back a little, as if apprehensive about David's reaction. The king, his crown and scepter on the table near his harp, seems about to rise from his chair, one foreshortened hand extended, perhaps ordering the prophet to be silent. Like a great theater director, Rembrandt explores the dramatic tension between the characters, communicating their relationship with a subtle understanding of each man's feelings.

54. **Cavaliere d'Arpino** (Giuseppe Cesari; Italian, 1568–1640)
Perseus Rescuing Andromeda, 1594/95
Oil on panel, 20¹¹⁄₁₆ × 14¹⁵⁄₁₆ in. (52.5 × 38 cm)
Acquired by the Clark, 2010, 2010.7

In his epic poem *Metamorphoses*, Ovid describes the hero Perseus flying on winged sandals to save Andromeda from the terrifying jaws of a sea monster. Giuseppe Cesari's *Perseus Rescuing Andromeda* depicts an alternative version of the story, in which Perseus sits astride Pegasus, one of the creatures that sprang from the neck of the Gorgon Medusa when her head was severed. The painting reconnects with Ovid's narrative in the figure of Andromeda. The poet describes her as looking like a statue—her flowing tears and hair waving in the breeze offer the only indications that she is a woman of flesh and blood. Cesari worked for a number of prominent patrons in Rome during the late sixteenth and early seventeenth centuries, including Pope Clement VIII, who gave him the title *cavaliere*, or "knight" (Arpino was his father's hometown). The story of Perseus and Andromeda—a classical myth about a vulnerable beauty and a courageous hero—was one of the artist's most popular subjects, and he produced several variants of the image.

55. **Joachim Anthonisz Wtewael**, (Dutch, 1566–1635)
The Wedding of Peleus and Thetis, 1612
Oil on copper, 14³/₈ × 16⁹/₁₆ in. (36.5 × 42 cm)
Acquired by the Clark, 1991, 1991.9

Classical narratives have inspired artists throughout the centuries. In Joachim Anthonisz Wtewael's painting, the gods of ancient Greece celebrate the marriage of the nymph Thetis to the mortal king Peleus. On the far right, Zeus and Artemis sit together, while Hermes, Dionysus, and a satyr help themselves to food and more wine. In the center of the composition, a pale-skinned Aphrodite reclines in the arms of Ares while her son Eros points an arrow of love at her breast. Behind this group, Peleus and Thetis look up at Eris, goddess of discord— who was not invited to the wedding. She arrives bearing a gift: the golden apple that provoked dissent among the gods and ultimately led to the Trojan War. Painting on smooth copper enabled Wtewael to include dozens of figures in complicated positions. Like other Mannerist artists, he worked for sophisticated patrons who would have been familiar with the details of the subject matter, including the next episode of the story: the judgment of Paris, which appears as a blue-tinted vignette in the background.

56. **François Boucher** (French, 1703–1770)
Vulcan Presenting Arms to Venus for Aeneas, 1756
Oil on canvas, 16¼ × 17¹³⁄₁₆ in. (41.2 × 45.3 cm)
Acquired by the Clark, 1983, 1983.29

François Boucher was an enormously prolific painter of narrative pictures, portraits, and landscapes. He also designed tapestries for the Gobelins factory in Paris and the Beauvais factory in northern France. *Vulcan Presenting Arms to Venus for Aeneas* is one of four designs that the marquis de Marigny—arts minister and the brother of Madame de Pompadour, Louis XV's mistress—commissioned from different artists. The decorative,

pastel colors and shimmering brushwork would have translated well into the threads of a large wall hanging, and they also suit the delicious sauciness of the subject matter. The story comes from Virgil's *Aeneid*: Venus asked her husband Vulcan to make arms and armor for her son, the Trojan hero Aeneas. In this wonderfully animated composition, Boucher focuses on an episode not described by Virgil in which the goddess returns to pick up the weapons. The original commission required the four designers to illustrate the love affairs of classical gods, and Boucher's painting invites us to infer from Venus's décolletage, that she has used her legendary beauty to seduce Vulcan into granting her request.

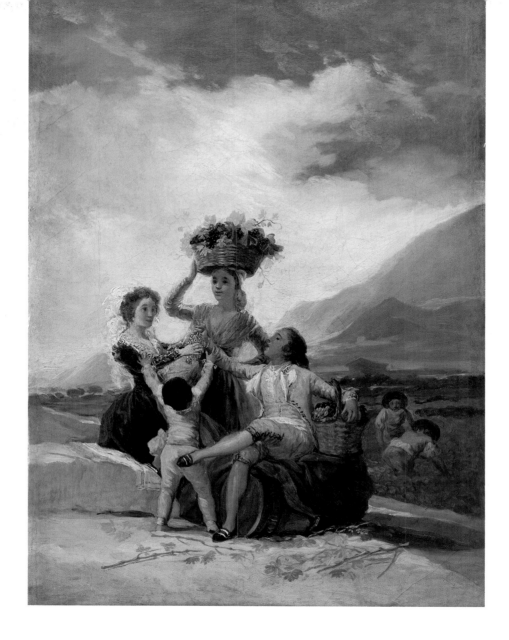

57. Francisco de Goya (Spanish, 1746–1828)

Autumn, 1786

Oil on canvas, 13³⁄₈ × 9⁹⁄₁₆ in. (34 × 24.3 cm)

Acquired by Sterling and Francine Clark, 1939, 1955.749

In 1786, the year he was appointed painter to the King of Spain, Francisco de Goya was commissioned to design a series of tapestries to decorate the dining room of El Pardo, the palace occupied at the time by the prince and princess of Asturias—later Charles IV and Queen Maria Luisa. The general theme of the tapestries was to be the four seasons. This small canvas is one of the designs shown to the king for his approval. It depicts an autumn scene on a terrace near a vineyard. A young gentleman in a stylish yellow suit sits on a wine barrel and offers a bunch of freshly harvested grapes to a lady in black. Between the two figures, a child stretches upward, irrepressibly trying to grab the fruit that is just out of reach. Behind this engaging group, laborers work in the fields and a female servant stands with a basket of grapes balanced on her head. The relationship between the figures in Goya's painting is carefully orchestrated, while the delightful handling of the paint gives the scene the appearance of a spontaneous sketch.

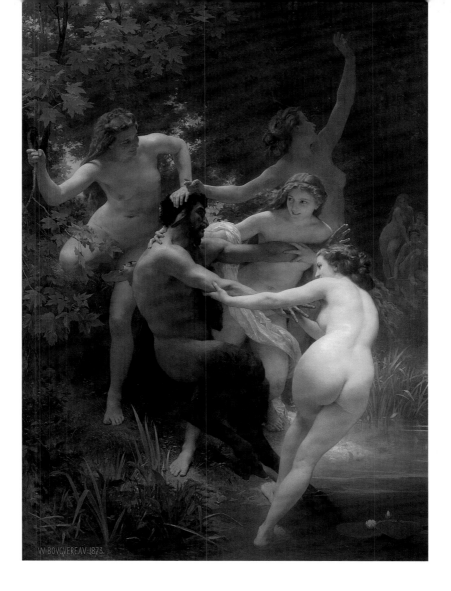

58. **William-Adolphe Bouguereau** (French, 1825–1905)
Nymphs and Satyr, 1873
Oil on canvas, 102½ × 72 in. (260.4 × 182.9 cm)
Acquired by Sterling and Francine Clark, 1942, 1955.658

William-Adolphe Bouguereau's *Nymphs and Satyr* demonstrates the continuing influence of the classical past on the art of the nineteenth century, and its wonderfully rhythmic composition indicates the painter's sophisticated understanding of design. Nymphs bathing in a woodland pond spot a satyr spying on them from the foliage. Satyrs—mythological creatures that are half-human, half-goat—were well-known symbols of uncontrollable physical passion. Four of the nymphs are attempting to drag the satyr from his hiding place and throw him into the cold water, to dampen his ardor and teach him a lesson.

The figures are painted in an almost balletic arrangement, and Bouguereau previously had worked out their intertwining poses in several preparatory studies. The painting was shown at the Paris Salon in 1873, and the American collector John Wolfe later purchased it. Subsequently, it was acquired by Edward Stokes, a convicted murderer, who hung it in the bar of the Hoffman House Hotel in New York City, of which he was part owner. Not surprisingly, it became very popular with the patrons and was reproduced in a variety of other contexts, notably on the inside of cigar box lids. The canvas was eventually placed in storage, where Sterling Clark saw it. When the Clarks bought the picture in 1942, they exhibited it in New York to raise funds for the Free French Forces during World War II.

59. **Sir Lawrence Alma-Tadema** (British, born Netherlands, 1836–1912)
The Women of Amphissa, 1887
Oil on canvas, 48¼ × 72½ in. (122.5 × 184.2 cm)
Acquired by the Clark, 1978, 1978.12

Classical themes continued to be popular in Britain throughout the nineteenth century. The London-based painter Sir Lawrence Alma-Tadema made several visits to Italy to gather visual material that would add a flavor of archaeological accuracy to his paintings. He sometimes included recognizable classical artifacts, like the circular plate that hangs near the fish stall in the background of *The Women of Amphissa*. The subject of the painting is a story told originally by the Greek historian Plutarch, and referred to in George Eliot's novel *Daniel Deronda*. Intoxicated by religious fervor, female followers

of Dionysus, the god of wine, found their way to Amphissa, a city with which their own hometown was at war. There they spent the night sleeping in the market square. The following morning the local women, in an act of female solidarity, protected the awakening revelers from danger and negotiated their safe passage home. The women in the foreground—barefoot and wearing short dresses, some with leopard skins, some with vine leaves in their hair—accept the nourishment offered by the more formally dressed women of the city. The painting was praised by critics in London and awarded a medal in Paris in 1889, though some commentators suggested that Alma-Tadema's female figures resembled Victorian ladies in fancy dress. One Victorian lady—the artist's wife, Laura—may have been the model for the blonde-haired women in the middle of the composition.

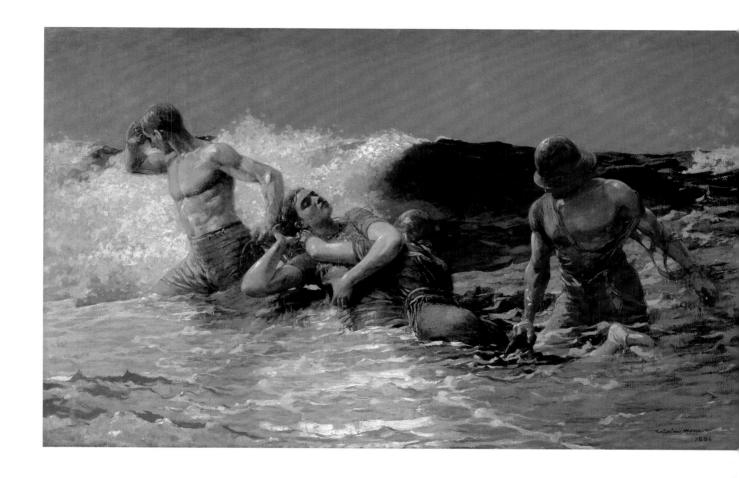

60. Winslow Homer (American, 1836–1910)
Undertow, 1886
Oil on canvas, 29¹³⁄₁₆ × 47⁵⁄₈ in. (75.7 × 121 cm)
Acquired by Sterling and Francine Clark, 1924, 1955.4

Homer based the painting *Undertow* on a real event, a rescue he had witnessed at the New Jersey shore. Two women, wearing voluminous bathing costumes, have been engulfed by an unexpected wave while taking the sea air. Their wet clothes cling tightly to their bodies, weighing them down. They hold on to each other desperately as their rescuers attempt to drag them to safety, the men's muscles straining against the waves and the current. Homer drafted this composition in a series of drawings (also now in the Clark's collection), altering gestures, poses, and the relationship of the figures to produce a satisfactory design. The figures demonstrate Homer's understanding of human anatomy and his awareness of classical sculpture—the three on the left fit neatly into a triangle, as if they have been lifted from the corner of a Greek temple pediment. The painting is a dramatic image of a contemporary event, but it also reflects the continuing influence of the art of the past.

61. **Edgar Degas** (French, 1834–1917)
Self-Portrait, c. 1857–58
Oil on paper, mounted on canvas, 10¼ × 7½ in.
(26 × 19.1 cm)
Acquired by Sterling and Francine Clark, 1948, 1955.544

Edgar Degas painted this self-portrait when he was in his early twenties. Having given up both his law studies and the formal training offered at the École des beaux-arts in Paris, he went to Italy to copy and learn from the work of Renaissance painters and other artists of the past. While in Rome, Degas saw a number of etchings by Rembrandt in private collections. This subtle self-portrait may reflect that experience. The artist wears a white painting smock over his brown jacket, with a daringly bright peach-colored scarf tied around his neck. Degas has focused his, and our, attention on the features of his own face, the top half of which is in the shadow cast by the brim of his hat. The bottom half is bathed in a soft light, revealing details painted with small strokes of the brush, while the bottom left portion of the painting remains relatively untouched.

62. **Edgar Degas** (French, 1834–1917)
Jules Taschereau, Edgar Degas, and Jacques-Émile Blanche, 1895
Gelatin silver print from glass negative, enlargement,
9 × 9¾ in. (22.9 × 24.8 cm)
Acquired by the Clark, 2002, 2002.6

Many nineteenth-century artists were interested in photography, with its variable depths of focus and occasional, almost accidental, cropping of figures and other details, and some artists incorporated those effects into their paintings (see cat. 37). Degas, who bought a camera in 1895, was fascinated by the idea of exploring his surroundings through the camera's lens. In this photograph, the artist sits between two friends, in a dark domestic interior. His head, seen in profile, is slightly blurred—he must have moved during the long exposure. He crosses one leg over the other, grasping his ankle with his left hand and resting his right hand on his knee. The image may seem improvised, but Degas orchestrated his photographs as carefully as he did his other works—the position of the angular *T* of the lamp in the exact center of the composition, for example, is surely no accident.

63. **Edgar Degas** (French, 1834–1917)
Entrance of the Masked Dancers, c. 1879
Pastel on paper, pieced, 19⁵/₁₆ × 25½ in. (49 × 64.8 cm)
Acquired by Sterling and Francine Clark, 1927, 1955.559

Degas's fascination with ballet is well known—his paintings, drawings, prints, and sculptures of ballet dancers are instantly recognizable and they formed a significant part of his life's work. Like other privileged supporters of the ballet, the artist was allowed backstage during performances. From his location in the wings he could see the dancers performing and in repose, relieved or fatigued, walking off stage and out of sight of the audience. This large pastel was almost certainly made in the artist's studio, though it preserves the sense of a live performance. The two dancers in the foreground are shown moving behind an irregularly shaped piece of scenery. Beyond them we can see a line of fresh performers in capes and black masks, tiptoeing across the boards. Degas drew the dancers' bodies in motion with broad sweeping gestures, leaving areas of solid color on the paper and adding finer contours here and there to bring some details into sharper focus. In the opposite wing, we catch a glimpse of a man in formal evening clothes. Like the artist—and like us—the man watches the performance from an unusual angle, a still presence amid the bustle of theatrical activity.

64. **Edgar Degas** (French, 1834–1917)
Dancers in the Classroom, c. 1880
Oil on canvas, 15½ × 34¹³⁄₁₆ in. (39.4 × 88.4 cm)
Acquired by Sterling and Francine Clark, 1924, 1955.562

Though he found the training offered at the École des
beaux-arts uncomfortably inflexible, Degas was nevertheless
committed to the act of drawing as the activity that under-
pinned all the visual arts. In this small, but panoramic, canvas,
the dancers have been painted and repainted, their poses
adjusted like the figures in an academic painting (see cat. 58),
as Degas worked out the composition. He even removed the
canvas from its stretcher and extended the painting by about a
centimeter along the top and a little more than that at the bot-
tom. The dancers rest or go through their exercises in a large
rehearsal room, their bodies posed so that our eyes are led
from the cropped figures in the foreground to the more distant
figures on the left. The standing dancer in the center connects
the two halves of the image. This precisely constructed compo-
sition reflects not only Degas's interest in drawing, perspective,
and photography but also his knowledge of the flattened forms
and sinuous lines found in the Japanese woodblock prints that
had begun to appear in Europe in the mid-nineteenth century.

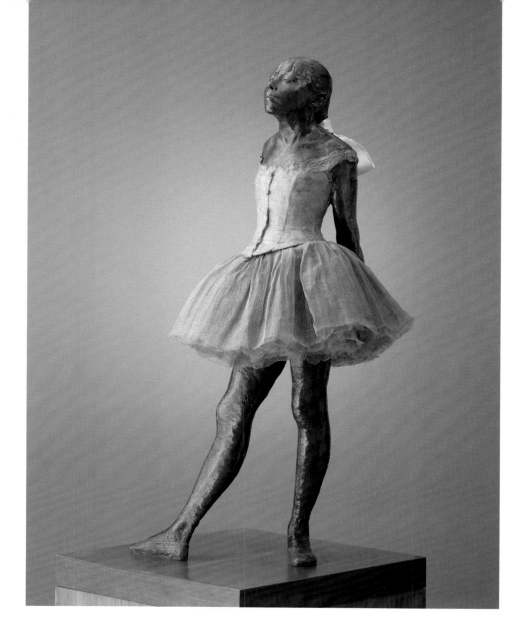

65. **Edgar Degas** (French, 1834–1917)
Little Dancer Aged Fourteen, modeled: 1879–81, cast: 1919–21
Bronze with gauze tutu and silk ribbon, on wooden base,
height: 39 in. (99 cm)
Acquired by Sterling and Francine Clark, probably in the 1920s,
1955.45

Degas was supposed to send his first public sculpture to the
fifth Impressionist exhibition in 1880, but it was not finished
to the artist's satisfaction in time, so the glass case in which
it would have been displayed remained empty when the
exhibition opened. *Little Dancer Aged Fourteen* appeared a year
later, in its original form—tinted wax, with a real costume
and real hair. The uncompromising realism of the sculpture
provoked both excited praise and severe criticism. Some critics
enthusiastically welcomed it as "modern," a work that opened
up new and exciting possibilities for the future of sculpture.
Others were vitriolic in their condemnation of what they felt
was ugly and vulgar, unidealized and unrefined. When the
exhibition closed, the statue went back to Degas's studio; he
never exhibited a piece of sculpture publicly again. The wax
version of the statue was not cast in bronze until after the
artist's death.

66. **Pierre-Auguste Renoir** (French, 1841–1919)
Portrait of Madame Monet (Madame Claude Monet Reading), c. 1874
Oil on canvas, 24⁵/₁₆ × 19¹³/₁₆ in. (61.7 × 50.3 cm)
Acquired by Sterling and Francine Clark, 1933, 1955.612

In the early 1870s, Renoir and Monet often worked closely together at the Monet family home in Argenteuil (see cat. 11). Renoir's *Portrait of Madame Monet* was probably painted around 1874, the year of the first Impressionist exhibition. Like the threads in a tapestry, small, lively touches of color cover every inch of the canvas. From the separate paint marks, the figure emerges, wearing a patterned house dress and seated—almost reclining—on a comfortable sofa. Madame Monet rests her feet on one of the soft sofa cushions. The thin blue line down the middle of her dress echoes the angle of the Japanese fans that hang on the wall behind her. Camille Monet was one of her husband's favorite models, and she also appears in several paintings by Renoir. In this intimate image, she seems entirely at ease, immersed in a paperback book, smiling slightly, and unselfconscious about the fact that she is the object of an artist's attention.

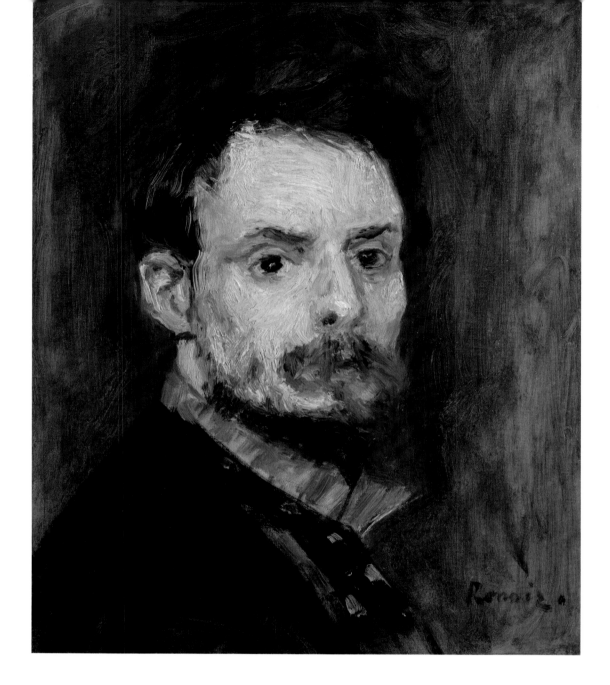

67. Pierre-Auguste Renoir (French, 1841–1919)
Self-Portrait, c. 1875
Oil on canvas, 15⅜ × 12⁷/₁₆ in. (39.1 × 31.6 cm)
Acquired by Sterling and Francine Clark, 1939, 1955.584

Renoir's self-portrait was exhibited at the second Impressionist exhibition in 1876. The painting technique is rather different from the artist's usual manner. While some areas of the canvas are thinly brushed with diluted washes of color, Renoir painted his face, hair, mustache, and beard very thickly, with what appear to be rapid touches of a heavily laden brush or palette knife. This picture may have been something of an experiment. Renoir explained sometime later that he was ready to discard the painting when his friend Victor Chocquet bought it. Later still, according to Renoir, Chocquet gave the artist 1,000 francs—the sum he had been paid by the Romanian doctor Georges de Bellio, who was keen to add the work to his collection of Impressionist paintings.

68. Pierre-Auguste Renoir (French, 1841–1919)
Onions, 1881
Oil on canvas, 15³⁄₈ × 23⁷⁄₈ in. (39.1 × 60.6 cm)
Acquired by Sterling and Francine Clark, 1922, 1955.588

Renoir painted this unusual still life during a visit to Italy in 1881; the artist's signature, date, and location—Naples—appear in the bottom left-hand corner of the canvas. The rounded forms of the onions, their luscious pink color, and the paper-thin layers of their brittle skins are painted with the same kind of sensuous delight that Renoir brought to his paintings of female nudes. By the end of the 1870s Renoir's success as a portrait painter enabled him to finance a trip to Italy, during which he was impressed by frescoes discovered in Pompeii and Herculaneum. The excavations of those archaeological sites revealed wall paintings and mosaics of various subjects, including erotic images of Roman deities and wonderfully realistic still lifes of flowers, fruits, and vegetables. *Onions* may have been painted as an homage to those earlier works.

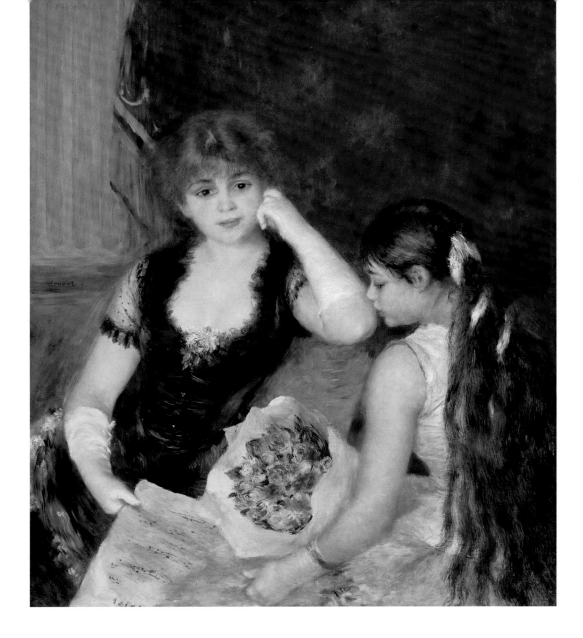

69. **Pierre-Auguste Renoir** (French, 1841–1919)
A Box at the Theater (At the Concert), 1880
Oil on canvas, 39⅛ × 31¾ in. (99.4 × 80.7 cm)
Acquired by Sterling and Francine Clark, 1928, 1955.594

During the 1870s, Renoir made several paintings of people watching stage performances from theater boxes or balconies. Toward the end of the decade he had begun to develop relationships with influential patrons, who commissioned him to paint portraits of themselves or family members. *A Box at the Theater*, painted in 1880, may have been intended as a portrait or may have been designed as another of Renoir's balcony pictures—a generalized image of well-to-do Parisians at leisure. The figures in this theater box, one of them young and innocent looking, the other more mature, are shown listening to a musical performance. Their costumes and hairstyles reflect the difference in their ages as well as their experience of the world: the young girl is shown with her hair down and wearing a white, high-necked dress and short gloves, while the older woman wears a more sophisticated ensemble. Another figure, a man in evening dress who once appeared in the top right-hand corner, was subsequently painted out, though from certain angles his head still can be seen beneath the red curtain.

70. Pierre Bonnard (French, 1867–1947)
Women with a Dog, 1891
Oil and ink on canvas, 16⅛ × 12¹³/₁₆ in. (41 × 32.5 cm)
Acquired by the Clark, 1979, 1979.23

Pierre Bonnard was one of several artists working in Paris at the end of the nineteenth century whose work reflected the influence of the Post-Impressionists, particularly the paintings and prints that Gauguin made in the South Seas and in Brittany (see cat. 40). In *Women with a Dog* Bonnard has brought together various elements—figures, color, texture, and the illusion of three-dimensional space—in an image that reflects the real world but does not slavishly imitate it. He flattened the checkered pattern of the dress worn by the young woman in the spotted scarf, and the form of her extended arm is delineated not by light and shadow, as it would be in "real life," but by contours drawn through the paint. Other three-dimensional forms were translated into colored shapes that complement each other on the surface of the canvas like areas of color in a Japanese woodblock print. The figures, dog, flowers, and back of the chair on which the woman in the center sits relate to each other in a pictorial pattern rather than as an attempt to mimic the appearance of the world outside of the painting.

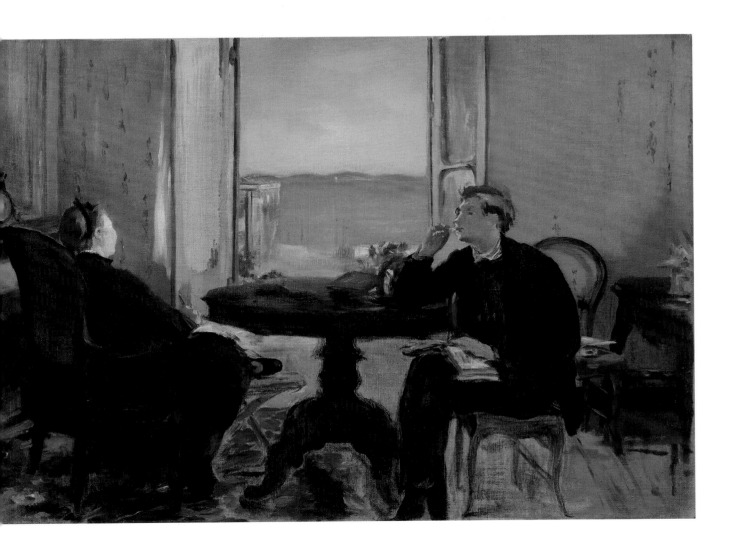

71. Édouard Manet (French, 1832–1883)
Interior at Arcachon, 1871
Oil on canvas, 15⁷⁄₁₆ × 21¼ in. (39.2 × 54 cm)
Acquired by Sterling and Francine Clark, 1943, 1955.552

While the Landes was being turned into a pine forest (see cat. 3), Arcachon, on the Gascony coast, was being developed as a bathing resort. Édouard Manet and his family rented a villa there in 1871, as their home in Paris remained inaccessible for some time after the end of the Franco-Prussian War. *Interior at Arcachon* shows the artist's wife, Suzanne, and her son, Léon, sitting on either side of a table, a window behind them open to a view of the bay. A patch of sunlight falls on Madame Manet's forehead, and delicate touches of light outline the young man's face. Elsewhere, the paint was applied quite thinly, not quite covering the canvas in the foreground— the image is reminiscent of an informal sketch, not intended for public viewing. Though the figures sit only a few feet apart, there seems to be very little communication between them; they face in different directions, staring past each other abstractedly, the shapes of their bodies outlined against the light.

72. Édouard Manet (French, 1832–1883)
Moss Roses in a Vase, 1882
Oil on canvas, 22 × 13⅝ in. (55.9 × 34.6 cm)
Acquired by Sterling and Francine Clark, 1923, 1955.556

Moss Roses in a Vase is one of the most lyrical paintings in the Clark's collection. A vase stands on a table spread with a white cloth. The far edge of the table is undefined; it seems to merge with the flat color of the wall beyond. Against the undemonstrative gray background, the luscious pinks of the rose petals, complemented by green foliage, fill the mouth of the vase. As our eyes move downward, we see touches of rich blue, white, and green that suggest the reflections of light shining on the surface of the glass. Below the waist of the vase, refractions bend the flowers' stems in the water. A single rose lies on the table, a horizontal accent that balances the artist's signature in the bottom right-hand corner of the canvas. Manet painted a number of flower still lifes during the months before his death, when his ill health prevented him from doing larger, more physically strenuous work. From this apparently simple subject matter, Manet distilled paintings of timeless beauty.

73. **Edvard Munch** (Norwegian, 1863–1944)
Madonna, 1895
Hand-colored lithograph on paper, image: 23⁹/₁₆ × 17⁵/₁₆ in.
(59.8 × 44 cm); sheet: 26¹/₁₆ × 18⁷/₈ in. (66.2 × 47.9 cm)
Acquired by the Clark, 1962, 1962.83

Edvard Munch's paintings and prints often explore the darker
recesses of the artist's imagination. The female figure in his
lithograph *Madonna* is shown in a pose similar to that of
the young woman in Morisot's painting *The Bath* (see cat. 42),
though the two images are completely different emotionally.
Munch's *Madonna* is a powerfully disconcerting figure, who
seems to display her naked body as an act of sexual provoca-
tion. Spermatozoa swim around her, their forms emphasized
by the red gouache that was added after the black lithograph
was printed. An embryonic child cowers in the corner. This
disturbing image refers to the Western tradition of depicting
the Virgin Mary and the infant Christ, but Munch's print
seems a caustic comment on a theme that usually emphasizes
tenderness and virtue.

74. **Erich Heckel** (German, 1883–1970)
Portrait of a Man, 1918
Color woodcut on paper, 18³⁄₁₆ × 12⁷⁄₈ in. (46.2 × 32.7 cm)
Acquired by the Clark, 2012, 2012.7

Like several German artists in the first half of the twentieth century, Erich Heckel explored the techniques of woodcut printmaking with an awareness of its traditions and an understanding of its expressive potential. In this powerful print, sharply cut black lines are printed over areas of textured color. They delineate the planes of the man's brow, his emaciated cheeks, and his penetrating stare. He leans his chin against his clasped hands, though whether or not he is praying is impossible to say. The curve of the shoulders tilting to one side adds a sense of imbalance to a psychologically intense image.

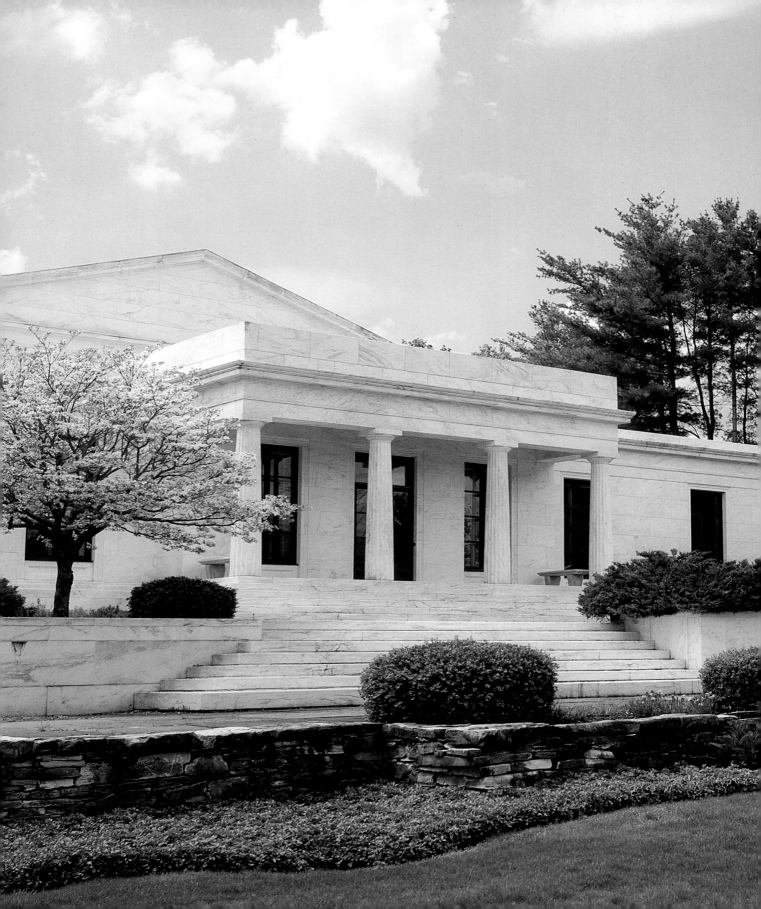

ARCHITECTURE AND SITE

The transformation of the Clark from its opening in 1955 to the present day is expressed, as it is also circumscribed, by its charter, its collections, and the design, spatial disposition, and functions of its buildings. The Clark's varied architecture summarizes the changing values and programmatic ambitions of the Institute, and the character of its buildings reflects the Clark's evolution from a museum dedicated to universal aesthetic values to its current place as a center for discussion and experience in all aspects of the visual arts, directed to a wide variety of audiences.

When Sterling Clark engaged architect Daniel Perry to design his museum, he wanted to create a classically styled, domestically scaled, and solidly constructed structure for the display of the collection he had carefully assembled over a forty-year period. Perry's deliberate evocation of the ancient Greek temple, with its neoclassical, white marble façade embodying the classical virtues of balance, harmony, and order, exhibited the hallmark of an arts institution as temple and memorial to aesthetic excellence—albeit one on a human scale (fig. 1). The goal of museological permanence expressed through proportion and detailing—somewhat reminiscent of the refined domesticity of the Frick Collection that Clark so admired—found its way into Perry's building in the form of vertically illuminated, intimate galleries. Though, in the Clark's case, the galleries were relatively spare and more museum- than house-like in their final execution, the domestic sensibility of the galleries remains, sustained not only by the Louis XVI–style decoration but also by the integration of paintings, sculpture, and decorative arts. The Clarks spent their last years living in a suite of galleries transformed into living quarters designed by Pierre Leclerc, the son of the interior designer who had worked on Sterling's home in Paris. The rooms included chandeliers and an antique marble mantelpiece

from the Clarks' apartment at the Ritz-Carlton in New York. Elements of those quarters remain today, most notably in the Alfred Stevens room, which served as the Clarks' dining room during their final years.

With Francine's death in 1960, three and a half years after Sterling's passing and only five years after the Institute opened, the Clark found itself at an important juncture. Unlike many institutions with mandates that require them to follow their founder's vision for decades, the Clark had no restrictive covenants in its charter that would determine a future institutional course; thus, the trustees were in a position to expand the programmatic direction of the Institute. The establishment of a research library and graduate program in art history as well as the need to accommodate a rapidly growing audience of visitors, especially in the summer months, encouraged the planning of a new building (fig. 2). Designed by the dean of architecture at the Massachusetts Institute of Technology, Pietro Belluschi, and Norman Fletcher of The Architects Collective, the new facility opened in 1973 after a decade of planning and construction. The Clark's growing commitment to scholarly

Fig. 1
Previous page, The original white marble building of the Clark Art Institute, designed by Daniel Perry and completed in 1955

Fig. 2
The Clark's red granite building, designed by Pietro Belluschi and The Architects Collective and completed in 1973. In honor of Sir Edwin A. G. Manton and his gift of more than two hundred works of British art, the building was renamed the Manton Research Center in 2007

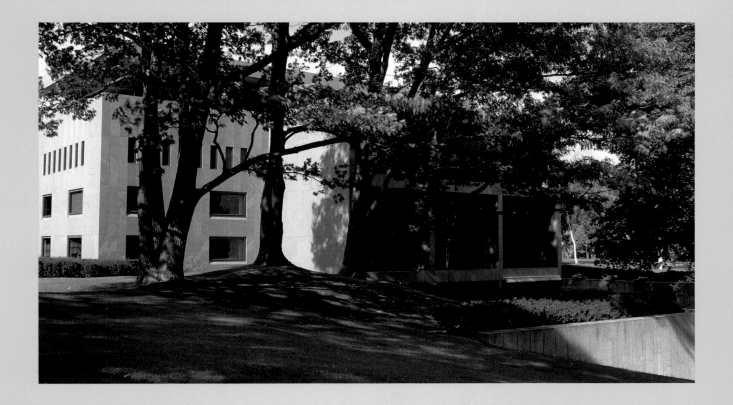

research, education, and an improved visitor experience necessitated new spaces for the nascent art research library and the newly conceived graduate program, a larger entrance lobby for visitors, more office space, and added galleries for the display of the growing collection. A commitment to music programming resulted in a critically acclaimed auditorium for chamber concerts, one that is now used for a wide variety of programs from lectures to theatrical performances (fig. 3). The new building reshaped visitors' experiences at the Clark while enabling a more diverse institutional program, including an ever-changing array of public events, concerts, lectures, and small-scale exhibitions. Metaphorically, the bridge that connects the original marble building to the red granite building reflects the Clark's evolving mission as both an art

Fig. 3
The auditorium in the
Manton Research Center
hosts a variety of programs

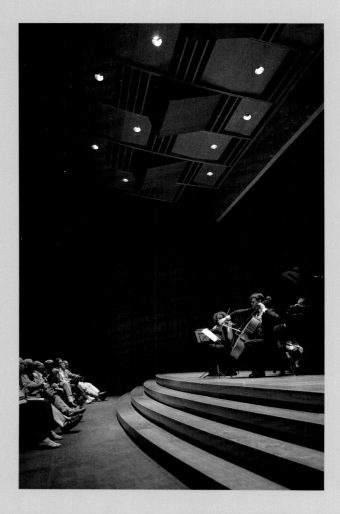

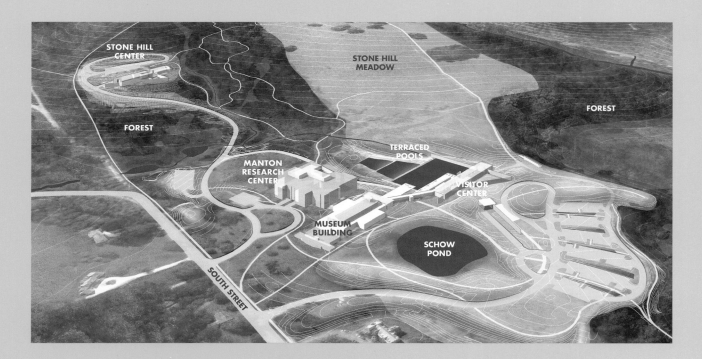

Fig. 4
Map of the Clark's
campus plan

museum and a center for research and higher education. In a similar fashion, the bridge now symbolizes the Clark's goal of making scholarship and critical perspectives in the visual arts more accessible to a broad audience.

A small but important expansion in the mid-1990s, designed by the Boston firm Ann Beha Associates, added an exhibition gallery, a public café, more offices, and additional library space for the Institute's growing Research and Academic Program. Shortly after, the Clark embarked on a planning process to address three long-term goals: Programmatically, there was a need for expanded temporary exhibition space, larger permanent-collection galleries, a new facility for the Williamstown Art Conservation Center, a dedicated study center for works on paper, and a space for added visitor services to accommodate increased attendance. Secondly, the Clark desperately needed to update its fifty-year-old infrastructure, from a fully secured and climatized loading dock to a new plant and a larger art storage facility. Finally, the Clark sought to make its 140-acre campus an important part of the visitor experience. Over the years, the Institute's upland trails had become an extension of the Williams College campus, but they were not a part of visitors' experiences, as the trails were rough and minimal.

After a comprehensive assessment of programmatic needs and visitor amenities, the trustees approved a master plan developed by the New York firm Cooper Robertson in early 2001 that would dramatically reconceive the Clark campus (fig. 4). Pritzker Prize–winning architect Tadao Ando and the landscape architecture firm of Reed Hilderbrand Associates were selected to articulate that plan, embracing the Clark's programmatic goals and responding to its beautiful natural surroundings while preserving the sense of intimacy that is a hallmark of the Clark experience. Recognized internationally as an architect

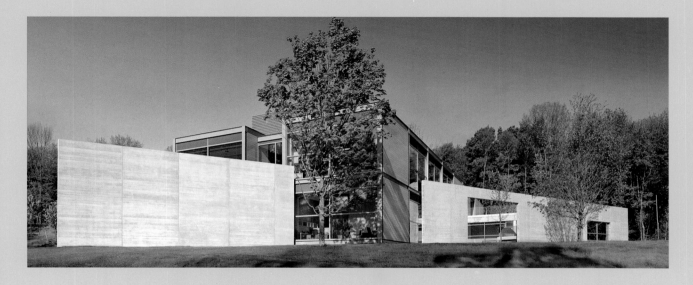

Fig. 5
Stone Hill Center, designed
by Tadao Ando and
completed in 2008

Fig. 6
Stone Hill Center galleries
and surrounding landscape

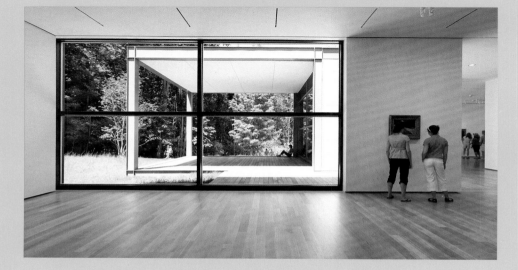

attuned to an expression of a modernist vision in the natural environment, Ando had shown himself capable of sensitively integrating his buildings into the landscape. He was also able to bring light into lower-level spaces, with the goal of ensuring a smaller-scale, above-grade building—thereby preserving the intimacy of the Clark.

The first phase of the Clark's campus expansion was completed in 2008 with the opening of a new building on Stone Hill (fig. 5). Perched on a wooded hillside southwest of the Institute's first buildings, Stone Hill Center houses a state-of-the-art facility for the Williamstown Art Conservation Center, a large classroom and meeting space, and intimate galleries dedicated to focused exhibitions that have added non-Western and contemporary art to the Clark's program (fig. 6). An expansive terrace affords a magnificent vista of Vermont's Green Mountains to the north, as it commands views of a growing network of scenic trails and walking paths that integrate the upper campus into the surrounding landscape.

The second and final phase of the expansion plan opened in July 2014, reorienting the entrance to the Clark through Ando's new visitor center (fig. 7). The metal and glass visitor center, enhanced by red granite and architectural concrete walls, adds substantial special exhibition galleries; a multipurpose

Fig. 7
The Clark's visitor center, designed by Tadao Ando and completed in 2014 (digital/photo rendering)

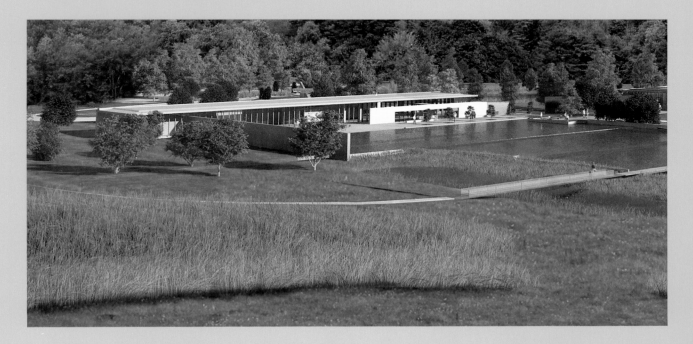

pavilion for conferences, lectures, and special events; dedicated space for family and community programming; and expanded visitor amenities, including new retail and dining facilities. The visitor center links to the original museum through a light-filled glass entry pavilion that forms a new west-facing entrance. The buildings border a reflecting pond uniting the campus with a garden that extends to the upland landscape.

New York–based architect Annabelle Selldorf was commissioned to renovate the original white marble museum building as well as the Manton Research Center. She approached the museum building renovation in a way that respects the architecture and does not disrupt the museum's original atmosphere and scale. Visitors enter the museum on an axis to enjoy newly restored galleries and added exhibition space dedicated to European decorative arts and American art, all of which have improved lighting and climate control systems. Selldorf's plans for the Manton Research Center reinforce its purpose as the center for research and academic programs. Renovations include the creation of a new Manton Study Center for Works on Paper (fig. 8), which provides greater access to the Clark's collection of prints, drawings, and photographs, as well as a new public reading room with an enhanced bookshop and information area and renovated galleries for the exhibition of works on paper.

Reed Hilderbrand Associates, working closely with Tadao Ando, implemented a sweeping new landscape design that highlights the beauty of the Clark's natural setting and enhances the sustainability of its unique

Fig. 8
The Manton Study Center for Works on Paper, completed in 2014 (digital rendering)

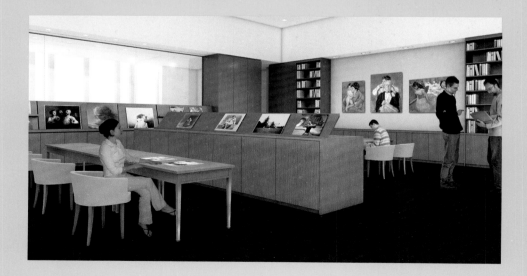

environment. The unifying element of the landscape design is a prominent reflecting pool—designed by Ando with the assistance of Reed Hilderbrand—that links the surrounding buildings with the natural setting (fig.9). The pool is also at the heart of sophisticated water engineering that significantly reduces the Institute's consumption of natural resources. By storing rainwater and runoff in cisterns for site irrigation, mechanical cooling, and wastewater flushing, the Clark has significantly reduced its use of potable water, despite the expansion of the campus. Those measures and numerous others that are part of the Clark's sustainability initiative underscore the Institute's commitment to and stewardship of its unique natural setting.

As the Clark has evolved architecturally since its opening, making its campus more accessible to the public in the process, it has transformed into a dynamic, multifaceted arts institution with global reach and significance. Founded as a private collection made public, the Clark is now home to a growing collection of art, critically acclaimed special exhibitions, and a series of popular and engaging public education programs. It is also a distinguished center for research, critical discussion, and higher education in the visual arts—a lively twenty-first-century institution, albeit one with a unique set of values emanating from its special history. Founded to house "the beauty of the ages" from one couple's collection, the modestly scaled art museum that Sterling and Francine Clark envisioned in the early 1950s is remembered in the museum's original building and in the display of its permanent collection; however, the original Clark bears only a casual resemblance to the expansive programmatic reach of the Institute today. Significant aspects of the Clarks' early vision remain—aesthetic quality and intimacy of experience especially—but now with the added goal of being an intellectual and educational center with the highest standards and impact. Together with dramatic natural surroundings that frame the campus, the Clark today represents an architectural legacy in a New England setting that, like the collection itself, will no doubt stand the test of time.

Fig. 9
The Clark's new visitor
center and central reflecting
pool, designed by Tadao
Ando and Reed Hilderbrand
and completed in 2014
(digital/photo rendering)

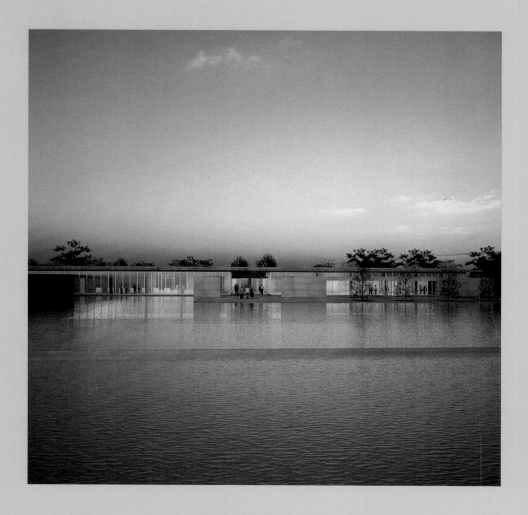

Art and the Material World

Most traditional works of art exist as physical objects that can be used in a variety of ways. Even paintings have useful functions—not only do they contain wonderful content for intellectual and visual enjoyment but they are also made to decorate walls, furniture, or chapels. Craftspeople have found ways to embellish every functional object—and the objects that find their way into museums are marked by something significant and special in design, craftsmanship, material, and meaning. Sterling and Francine Clark had a deep love of beautiful and well-crafted things, including paintings, drawings, silver, and porcelain. Their original collection has been enriched by the generosity of other collectors who also shared a passion for objects of outstanding craftsmanship. An elegant contour, a sensitively applied decoration, or a delicate piece of carving or engraving can prompt our appreciation of those works, and once that appreciation has been stimulated, it can be extended and enriched each time we engage with a work of art.

75. **Honoré Daumier** (French, 1808–1879)
The Print Collectors, c. 1860–63
Oil on panel, 12 1/16 × 16 in. (30.7 × 40.7 cm)
Acquired by Sterling and Francine Clark, 1925, 1955.696

The Print Collectors captures the intense interest of connoisseurs as they lean together for a better look at the print held by the man in gray. Their faces show different reactions—admiration, satisfaction, questioning reserve, critical appraisal—as they discuss the merits, perhaps even the authenticity, of the work; the contrast of light and shade heightens the sense of an excited conversation. In the Clark's painting, prints and portfolios are strewn across the table and other pictures hang in smart frames behind the collectors. The men may not share the same opinion about the print they are examining, but the mood of Daumier's work indicates that they are in enthusiastic agreement about looking at and collecting works of art.

76. Gustave Le Gray (French, 1820–1884)
Brig on the Water, 1856
Albumen print from wet-collodion-on-glass negative,
12⅝ × 16¼ in. (32.1 × 41.3 cm)
Acquired by the Clark, 1998, 1998.32.3

When photography was invented in the 1830s, opinions varied about whether the new medium was an art or a science, a useful technology, or a problematic rival to the art of painting. Gustave Le Gray's work fueled that debate. Like many early photographers, Le Gray had trained as a painter, and he retained a painter's eye for composition and dramatic lighting. Early photographic processes required long exposure times and it was difficult for landscape photographers to achieve a comfortable balance between a light-filled sky and the shadowy solidity of the ground. In *Brig on the Water*, however, the light in the sky is reflected on the waves and consequently, the two elements are closer to each other in tone. Le Gray's remarkable seascape was praised as a photographic masterpiece on both sides of the English Channel when it was exhibited in London and Paris in 1856 and 1857.

77. Giovanni Antonio Boltraffio (Italian, 1466 /1467–1516)
Head of a Woman, early 1490s
Metalpoint heightened with white on paper, 5⁷/₈ × 4⁷/₈ in.
(15 × 12.4 cm)
Acquired by Sterling Clark, 1917, 1955.1470

Giovanni Antonio Boltraffio made this exquisitely modeled drawing in metalpoint—a technique that involves using a finely rolled metal filament held in a sheath, like a modern mechanical pencil. The artist traced the tip of the wire across a prepared sheet of paper, leaving behind a series of fine lines. The young woman, with her tender expression and cascades of waving hair, resembles the Virgin Mary in several of Boltraffio's paintings. Boltraffio was a pupil of Leonardo da Vinci, and at some point in its history—perhaps while it belonged in the collection of the seventeenth-century painter Peter Lely, whose initials appear in the bottom right-hand corner of the paper—this drawing was attributed to Leonardo, hence the inscription in the bottom left.

78. Jean-Antoine Watteau (French, 1684–1721)
Studies of a Flutist and Two Women, c. 1717
Red, black, and white chalk on paper, 10¹⁄₂ × 9¹⁄₁₆ in.
(26.7 × 23 cm)
Acquired by Sterling and Francine Clark, 1935, 1955.1839

The wistful, sometimes melancholic, mood of many of
Jean-Antoine Watteau's finished paintings is conjured from
a variety of elements, including beautifully modeled figure
studies like the ones on this sheet. Using red and black chalks,
with touches of white for the highlights, Watteau drew the
heads and shoulders of two female models—one fresh-faced
and slightly coquettish, the other a little older and more
serious, but both of them convincingly vivacious. On the left
of the paper, the artist included the full-length figure of a man
playing a flute, possibly a musician from a *commedia dell'arte*
troupe. With a very limited number of fluid lines, Watteau
suggested the flowing folds of the man's costume, the turn
of his waist, and the perfect poise of his head and arms as he
holds the instrument to his lips and moves his fingers up and
down the sound holes.

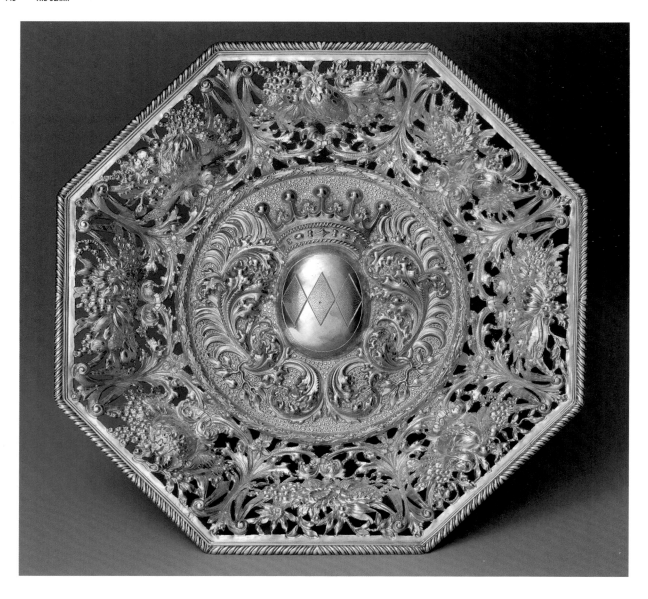

79. **George Lewis** (English, active 1691–1714)
Basket, c. 1700
Silver, 3¼ × 13¾ × 13¾ in. (8.3 × 34.9 × 34.9 cm)
Acquired by the Clark, 1987, 1987.57

An earl's coronet sits above the coat of arms in the center of this octagonal silver basket. Much of the fine patterning was hammered into relief from the back of the silver—a technique known as repoussé—while the borders are extensively pierced. The maker, George Lewis, registered as a silversmith in 1699, and the arms are those of the Earl of Montagu, who became a duke in 1705; therefore, although the basket bears no date hallmark, it can be dated with some accuracy. The basket was probably not meant to be used. It is likely to have been displayed in a prominent place where its swags, foliage, and fruit would have attracted admiring compliments.

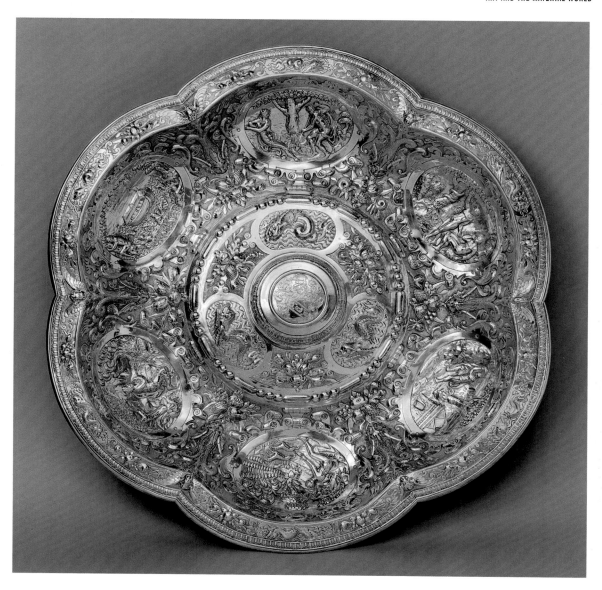

80. Maker's mark "IV" with star below (British)
Basin, 1618/19
Silver, 2½ × 20 × 20 in. (6.4 × 50.8 × 50.8 cm)
Acquired in honor of Charles Buckley, 1989, 1989.2

Basins and ewers containing water scented with rose petals were essential items in the dining rooms of well-to-do European homes before the use of forks became common. This heavily decorated silver rosewater bowl—and the ewer that would have accompanied it—surely must have been made for a special occasion, probably by one of the many Dutch silversmiths who immigrated to Britain in the seventeenth century. Embossed and engraved designs cover every inch of the concave surface, including small-scale oval reliefs based on engravings by Étienne Delaune illustrating stories from Hebrew scripture. While the decorative designs surrounding the ovals were part of the common vocabulary of seventeenth-century silver decoration, the Biblical scenes are very unusual. The raised circular boss in the center of the bowl is detachable, presumably so that it could be replaced or reengraved with a new coat of arms when the basin passed from one family collection to another.

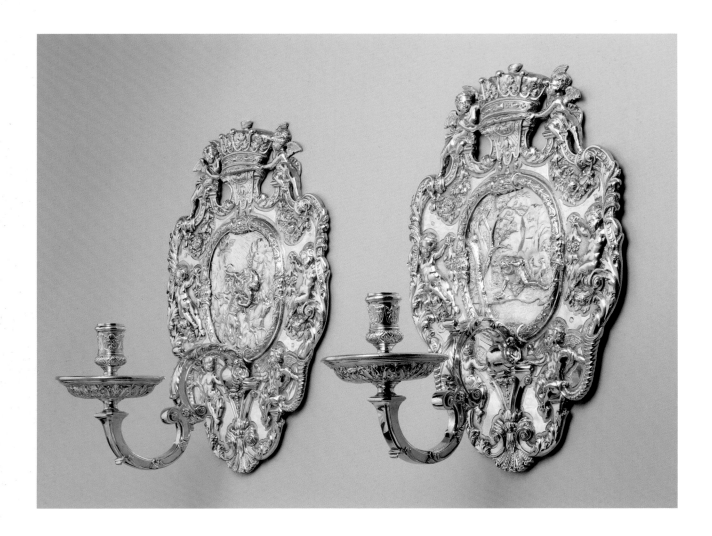

81. **Peter Archambo I** (English, active 1720; died 1767)
Pair of Wall Sconces, 1730/31
Silver, each approx. 16$^1/_{16}$ × 11$^3/_4$ × 9$^5/_{16}$ in.
(40.8 × 29.8 × 23.7 cm)
Acquired by the Clark, 1991, 1991.18

These extravagantly ornamented sconces were originally part of an impressive silver collection amassed by George Booth, second Earl of Warrington. They come from a set of six made by Peter Archambo I for the earl's bedchamber at his country estate, Dunham Massey, in northern England. In the center of the backing shields, each of the sconces is decorated with an image modeled in relief and illustrating a story from Ovid's

Metamorphoses. In one of the scenes, Phaeton, son of Helios, the sun god, is shown falling from his father's chariot after being struck by Zeus's fateful lightning bolt. In the other relief, Narcissus leans over a still pond, transfixed by his own beauty, while the nymph Echo looks on helplessly. Booth inherited his title from his father, along with almost insurmountable debts, a situation he resolved by marrying a woman with a large dowry. Unfortunately, the marriage was not happy and the earl and countess lived separately, in different parts of their country house. In later life the earl anonymously published an essay advocating divorce on the grounds of incompatibility. It has been suggested that the tragic subjects chosen to decorate the sconces are a reflection of the unhappiness of the marriage.

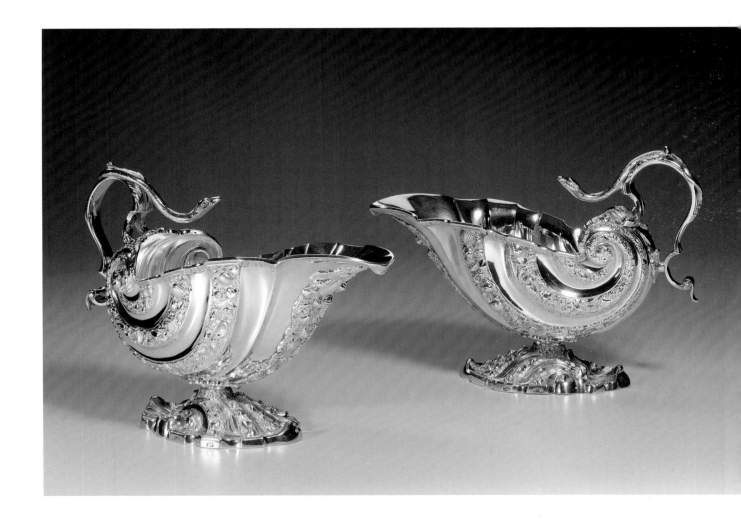

82. **Paul Crespin** (English, 1694–1770)
Pair of Sauce Boats, 1746/47
Silver, each approx. 6³/₁₆ × 8¹/₂ × 4 in. (15.7 × 21.6 × 10.2 cm)
Acquired by the Clark, 1986, 1986.21

Like many eighteenth-century English silversmiths, Paul Crespin came from a family of French Huguenots who moved to

Britain when Louis XIV outlawed their Protestant faith. These splendid sauce boats imitate the natural form of a shell. Smaller scallop shells can be seen decorating the curved sides; their shapes appear like fossils revealed by an archaeologist's brush. Miniature serpents raise their heads on the handles, a detail that is both ornamental and practical, as it would be a useful place for the pourer to rest his or her thumb.

83. **Paul de Lamerie** (English, 1688–1751)
Two-handled Cup and Cover, 1742/43
Silver, 15½ × 9³⁄₁₆ × 6¼ in. (39.4 × 23.3 × 15.9 cm);
base diameter: 5 in. (12.7 cm)
Acquired by Sterling and Francine Clark, 1931, 1955.413

This extensively ornamented ceremonial cup is one of several made by the silversmith Paul de Lamerie in London in the mid-eighteenth century. Its shape is essentially symmetrical, but its decorations include an enormous variety of abstract and natural forms. The infant Bacchus, Roman god of wine, appears surrounded by lions, scrolls, shells, and other imaginative ornamental touches, including a miniature lizard that rests on the highest tip of the cover. Born in the Netherlands, de Lamerie came from a family of French Huguenots. He served his apprenticeship in Britain, where he learned the practical skills of working in precious metals and acquired a vocabulary of decorative forms that was popular with wealthy clients at the time. Eventually, de Lamerie became one of the most accomplished and successful silversmiths of his age.

84. **Ignaz Joseph Würth** (Austrian, active 1770–1800)
Soup Tureen and Stand, 1779–81
Silver, 14¾ × 27⅛ × 17¾ in. (37.5 × 68.9 × 45.1 cm)
Acquired by the Clark, 1996, 1996.1

This splendid soup tureen and its elegant stand were part of a four-hundred-piece dinner service made by Ignaz Joseph Würth in the late eighteenth century for the Duke and Duchess of Saschen-Teschen. An impressively accurate silver still life of assorted vegetables on the cover is only one element of the tureen's lavish decorations. The body is fluted and engraved with abstract and foliated designs, and its handles and feet are formed from the coiled scaly bodies of sea creatures—to call them simply "fish" would surely be an understatement. Duchess Maria Christina was the favorite daughter of Empress Maria Theresa of Austria and the older sister of Marie Antoinette, Queen of France. She and her husband, Duke Albert Casimir, amassed an extensive collection of silver and other treasures, many of which are now housed in the Albertina Museum in Vienna.

85. **Paul Revere** (American, 1735–1818)
Sugar Bowl and Cover, c. 1795
Silver, 9⅜ × 4⁵⁄₁₆ in. (23.8 × 11 cm)
Acquired with funds donated by Henry Morris and
Elizabeth H. Burrows, 1987, 1987.108

When Britain's American colonies declared their indepen-
dence in the later eighteenth century, the new United States
modeled itself on the civilizations of ancient Greece and Rome
in several ways, including reusing architectural forms and
other design elements from the classical past. The American
patriot Paul Revere—famous for his Midnight Ride to Concord
in 1775 (described in the poem by Longfellow)—was a man of
many talents. At various times, he operated as a dentist, ran
factories that produced goods made from iron and copper, and,
most significantly, worked as an extremely skillful silversmith,
making and engraving cutlery, tankards, teapots, buckles, and
other items for middle- and upper-class clients in Boston and
the surrounding region. The form of Revere's silver sugar
bowl mimics the shape of a Roman funerary urn, its engraved
decorations are adapted from antique models, and even the
finial on the lid is reminiscent of the sacred flame tended by
the Vestal Virgins. This tasteful piece of tableware was made
for Sarah Sargent Ellery, whose initials are engraved on the
body of the urn in ornately curving script.

86. **Obadiah Rich** (American, active 1830–1850)
Tea Canister, 1845
Silver, 6 × 5 × 4 in. (15.2 × 12.7 × 10.2 cm)
Bequest of Henry Morris and Elizabeth H. Burrows, 2003,
2003.4.220

This octagonal tea canister made by the silversmith Obadiah
Rich is decorated with refined sprigs of foliage that spring
from the base and provide ornate frames for a series of small

landscape scenes. Around the curling fronds, incised parallel
lines give the leaf shapes the appearance of relief decorations.
Rich was one of Boston's most distinguished and successful
silversmiths in the 1840s and '50s. Unfortunately, his eyesight
began to fail in his fifties and he did less silversmithing as a
result, though he remained a partner in his company until
1865. This tea canister was made in 1845 for Emily Warren
Appleton, perhaps on the occasion of her wedding. Her initials
appear, in old English script, on the front panel.

87. **Johann Erhard Heuglin II and others**
(German, active 1717–1757)
Breakfast Set, c. 1728–29
Gilded silver, hard-paste porcelain, and glass with original
leather case, 10⁹/₁₆ × 19³/₈ × 14¹/₂ in. (26.8 × 49.2 × 36.8 cm);
contents: variable dimensions
Acquired by the Clark, 2012, 2012.4

For centuries the prosperous city of Augsburg in southern
Germany was a center of production for art and luxury goods
that found their way to courts and aristocratic homes across
Europe. Such luxury wares were visual demonstrations of the
affluence and refined taste of their owners, and while they
appear to be functional, most were meant for ostentatious
display. This breakfast set—assembled by either the goldsmith
Johann Erhard Heuglin II, who marked most of the gilded
silver pieces, or an agent who coordinated the assembly of
such luxury kits—is a splendid example of sophistication and
ingenuity. Finely made and beautifully ornamented cutlery,
glassware, gilded silver, and porcelain tableware rest snugly in
the niches of a tooled leather box lined with green velvet; each
slot is a perfect fit for the piece it was designed to accommo-
date. When open, the box allows for a tantalizing display of
dazzling luxury.

88. **Jacques Nicolas Pierre François Dubuc**
(French, active c. 1790–1830)
Mantel Clock, c. 1815–19
Gilded brass, iron, glass, 18⁹⁄₁₆ × 14⁵⁄₈ × 5⁵⁄₈ in.
(47.1 × 37.1 × 14.3 cm)
Gift of Mr. and Mrs. Robert W. Chambers, Jr., 1997, 1997.10.3

After the American Revolution, images of George Washington appeared in every conceivable context, including paintings, prints, public monuments, and decorative objects. This gilded bronze mantel clock was made in Paris for export to the United States as a commemorative piece after Washington's death in 1799. A three-dimensional figure of Washington stands in military costume, one hand on the hilt of his sword and his other arm resting on the case of the clock, near an American eagle perched on a globe. The words "First in War, First in Peace, First in the Hearts of his Countrymen" are embossed on a draped swag below the dial. The theme of Washington's service to his country is continued in the relief decoration on the base, which shows the general resigning his commission as commander in chief of the army.

89. *Desk and Bookcase* (American, Boston, c. 1770)
Mahogany and brass, 97³/₈ × 47³/₈ × 25¹/₄ in.
(247.3 × 120.3 × 64.1 cm)
A gift of the estate of Florence Cluett Chambers, 2001, 2001.1.2

In the eighteenth and early nineteenth centuries, American furniture builders incorporated a wide range of decorative elements into their designs, many of which were adaptations of features from classical architecture. Broken pediments, scrolls, pilasters, and other details appear frequently in furniture that includes chairs, chests of drawers, and long-case clocks from the period. Made in Boston around 1770, this elegant piece of furniture incorporates a chest of drawers, writing desk, bookcase with adjustable shelves, and brass handles and hinges. Fluted pilasters decorate either side of the upper portion, and two crests with carved rosettes and three turned finials add graceful curves to the top. Four cabriole legs ending in distinctive, finely carved animal paws support the base.

90. American Flint Glass Works
(American, 1764–1774)
Pocket Bottle, c. 1770
Amethyst glass, 4^{15}/$_{16}$ × 3^{1}/$_{2}$ × 2^{11}/$_{16}$ in. (12.5 × 8.9 × 6.9 cm)
Acquired with funds donated by June Lauzon, 1998, 1998.36.2

This pocket bottle or flask was probably made by American
Flint Glass Works in Manheim, Pennsylvania, sometime during
the early 1770s, a period in which many skilled European glass-
blowers were employed to produce fine glassware and pass on
their skills to local workers. The rounded, bulbous body of the
flask is decorated with repeated diamond shapes inset with
flowers. Known as "diamond daisy" patterning, the effect is
achieved by blowing molten glass into a patterned mold.
The hot glass is removed from the mold and then blown to a
larger size, expanding and softening the pattern. Bottles
of this kind were often used to contain alcoholic beverages or
perfume. The strikingly beautiful amethyst color was produced
by adding the chemical compound manganese dioxide as a
pigment.

91. Probably Boston and Sandwich Glass Works
(American, 1826–1888)
Decanter and Stopper, c. 1826–35
Colorless lead glass, 10³/₁₆ × 4⁹/₁₆ × 4⁹/₁₆ in.
(25.9 × 11.6 × 11.6 cm)
The Albert and June Lauzon Collection of Early American
Blown Glass, 1981, 1981.103

Silversmiths and ceramics manufacturers usually marked their
wares with symbols that identified their origins. Eighteenth-
and nineteenth-century American glassmakers, on the
other hand, often left no marks on their products, making
identification difficult. This blown-glass decanter was probably
made at the Boston and Sandwich Glass Works sometime in
the late 1820s or early 1830s, when cut glass—and molded
glass that resembles cut glass—was very popular. Glass cutting
is a delicate operation that requires considerable skill. As an
alternative, decanters like this one were made by blowing
a bubble of molten glass into a mold, thereby transferring
the decorations inside to the outer surface of the vessel. The
variegated textures reflect light in different ways, making the
decanter sparkle attractively. The blown-glass stopper, which is
shaped like a large acorn, is unusual.

92. **Lippert and Haas Porcelain Manufactory** (Bohemian, Schlaggenwald, c. 1808–1847)
Johann Zacharias Quast, painter (Bohemian, 1814–1891)
Plate, 1840
Hard-paste porcelain, diameter: 10 in. (25.4 cm)
Acquired by the Clark, 1996, 1996.7

Plates like this one, which is decorated with carefully observed insects and arachnids, were probably intended as collectors' items or demonstration pieces, rather than for use in a dinner service. This plate was made in the Lippert and Haas Porcelain Manufactory—the first such factory in Bohemia (now part of the Czech Republic)—and the skillful artist Johann Zacharias Quast painted its delicate surface decoration. The inscription, "Nach der Natur…" insists that Quast painted directly "from nature," perhaps making use of entomological collections assembled by the manufactory. Each of the creatures on the plate was painted in illusionistic detail, the hard glossy bodies of the beetles as convincingly reproduced as the delicate camouflage of the moths' and butterflies' wings. Each bug also casts a painted shadow on the white porcelain glaze—a satisfying detail that enhances the pretense of reality.

93. Vincennes Porcelain Manufactory
(French, c. 1740–1756)
River God, c. 1750
Soft-paste porcelain, 11⅛ × 10⅛ × 8¾ in.
(28.3 × 25.7 × 22.2 cm)
Acquired by the Clark, 1972, 1972.13

This small-scale figure of a river god—modeled with great sensitivity, probably by the sculptor Louis-Antoine Fournier—was made at the Vincennes Porcelain Manufactory in the mid-eighteenth century. It echoes the form of an antique Roman statue of the River Tiber. The god reclines on the back of a dolphin with one arm around its tail, while holding a paddle in his other hand. Water pouring from the dolphin's mouth turns into a shell around the base. The flowers at the god's feet are practical as well as decorative—they cover splits in the porcelain that appeared during the drying process. The Vincennes factory subsequently became the Royal Porcelain Factory at Sèvres, and it delivered countless splendid dinner services and other items made from soft-paste porcelain to the dining rooms and parlors of the wealthy throughout the eighteenth century. The company is still in business today.

94. Jacques-Henri Lartigue (French, 1894–1986)
Avenue du Bois de Boulogne, Paris, January 1911, 1911
Gelatin silver print, 2¹¹⁄₁₆ × 4⁷⁄₁₆ in. (6.8 × 11.2 cm)
Acquired by the Clark, 1998, 1998.32.1

This photograph of a woman strolling with her dogs in the Bois de Boulogne perfectly captures high society in the French capital between the turn of the twentieth century and the chaos of World War I. Like a character from a novel by Colette, this elegant figure, wrapped in fox furs and wearing a wide-brimmed picture hat, strides confidently with one stylishly shod foot peeping out beneath her dress. She seems entirely aware of being observed by the young man with the camera—Jacques-Henri Lartigue was seventeen years old at the time—and her body language suggests that she thinks this attention is exactly what she deserves. Carriages pass by in the background—both horse-drawn and horseless—clearly, the times are changing. With sharp intelligence and delicious wit, Lartigue fixed forever an image of "gay Paree" in the popular imagination.

95. **Alfred Stieglitz** (American, 1864–1946)
The Terminal, 1893; printed, c. 1910
Photogravure in original frame, 10 × 13⅛ in. (25.4 × 33.3 cm)
Gift of Penelope Tyson Adams in memory of her husband,
John Barclay Adams, 2010, 2010.13

In 1892 Alfred Stieglitz acquired his first handheld camera and
that winter he took this famous photograph of a Harlem street-
car driver tending to his horses. Snow cleared from the street
is piled on the sidewalk, and the warm bodies of the horses
are steaming in the freezing weather. Unlike the woman in
Lartigue's photograph of the Bois de Boulogne (cat. 94),
who seems delighted to be caught by a camera's lens, the man
in Stieglitz's picture has his back to the photographer, seem-
ingly concerned only with getting his streetcar back on the
road. Stieglitz records this everyday downtown scene with
the opportunistic eye of a newspaper reporter and the visual
sensitivity of an artist.

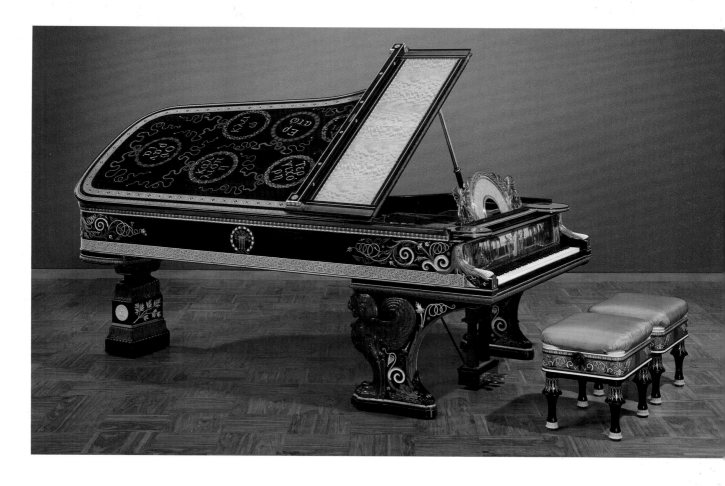

96. **Sir Lawrence Alma-Tadema** (British, 1836–1912),
Sir Edward John Poynter (British, 1836–1919),
Johnstone, Norman, & Company, London, and
Steinway & Sons, New York
Model D Pianoforte and Stools, 1884–1887
Ebony veneer with boxwood, sandalwood, cedar, ivory, coral,
mother-of-pearl, copper, brass, and pewter, 40³⁄₁₆ × 104³⁄₄ ×
59¹³⁄₁₆ in. (102.1 × 266.1 × 151.9 cm)
Acquired by the Clark, 1997, 1997.8

In addition to painting images of classical themes (see cat. 59),
Alma-Tadema designed theater productions, textiles, and
furniture. In 1884 the American millionaire Henry Marquand
commissioned him to design decorations for the music room
in Marquand's Manhattan home. Central to the furnishings of
the room was this splendidly ornate piano constructed of pre-
cious materials that include ivory, coral, and mother-of-pearl.

'The working parts of the instrument were built and installed
in the United States by Steinway & Sons. They also made the
piano case frame, which was shipped to London, where the
eleborate veneers—including classical patterns, Greek keys,
egg-and-dart molding, mythological creatures, and inlaid
wreaths—were done by Johnstone, Norman, & Company.
Sir Edward John Poynter—who, like Alma-Tadema, earned a
reputation in Victorian Britain as a painter of mythological
subjects—painted the image on the inside of the keyboard lid.
It is a variation on another work by Poynter that depicts the
Horae, the ancient Greek goddesses of the seasons. Inlaid on
the lid of the piano are the names—in Greek—of Apollo and
the Muses, patrons of the performing arts. Other names appear
on the inside of the lid, namely, the signatures of famous
composers and musicians, including Gilbert and Sullivan and
Richard Rodgers, who played the magnificent instrument.

97. Jean-Baptiste Carpeaux (French, 1827–1875)
Daphnis and Chloë, 1874
Marble, 55⅛ × 29⅛ × 22⁷⁄₁₆ in. (140 × 74 × 57 cm)
Acquired by the Clark, 2013, 2013.5

Alexander Hugh Baring, fourth Baron of Ashburton, a British politician, and a member of a wealthy family of investment bankers, commissioned this statue of Daphnis and Chloë from the French sculptor Jean-Baptiste Carpeaux in 1873. Daphnis and Chloë, characters from a Greek romance, grew up together as shepherd and shepherdess and eventually—almost inevitably—fell in love. Daphnis raises his hands tenderly to Chloë's face and almost brushes her cheek with his lips; the couple's uncertain body language suggests their youth and inexperience. The sensitive carving of the marble mimics smooth, soft, youthful flesh, making the sculpture at once romantic and charming, sensuous and innocent.

98. **Jules Dalou** (French, 1838–1902)
Bacchus and Ariadne, 1894
Marble, 32⁵⁄₁₆ × 20 × 18 in. (82 × 50.8 × 45.7 cm)
Acquired by the Clark, 1996, 1996.3

In this remarkable sculpture group by Jules Dalou, an infant satyr, or faun, accompanies Bacchus, the god of wine, as he leans over to support a sleeping Ariadne. With Ariadne's assistance, the hero Theseus had killed the Minotaur, the pet monster with a man's body and a bull's head that had belonged to Ariadne's father, King Minos of Crete. Subsequently, in a less than heroic act, Theseus abandoned Ariadne on the island of Naxos, sailing home to Athens without her. Returning from a revel, Bacchus found the princess sleeping on the beach and immediately fell in love with her. He woke her with a kiss and turned her crown into a constellation to make her immortal. The polished marble of Dalou's marvelous sculpture suggests the textures of Ariadne's soft flesh as well as the taut muscles of Bacchus's upper body. The tenderness with which the god embraces his lover and the delicate lift of her little finger and her slight frown as she struggles to wake up are subtle details carved with great sensitivity.

PHOTOGRAPHY CREDITS

Permission to reproduce illustrations is provided courtesy of the owners listed in the captions. Unless otherwise noted, photographs of works belonging to the Clark Art Institute are by Michael Agee.

Additional photography credits are as follows:

p. viii: Michele Slowey-Ogert

p. x: Smithsonian Institution Archives. Image 2005-5051

p. 2, 6, 12, 44, 50, 51: Clark Art Institute Archives

p. 3: Photo by George Blodgett. Dry Collodion Negative. N0290.1944(001), PH5271. Fenimore Art Museum, Cooperstown, New York

p. 4 (*inset maps*): Metrohistory.com

p. 5: Photo by Arthur J. Telfer (1859–1954). Dry Collodion Negative. 7-01,640. Smith and Telfer Collection, Fenimore Art Museum, Cooperstown, New York

p. 7 (*left*): ©Coll. Comédie-Française

p. 7 (*right*): Bibliothèque nationale de France, Coll. Nadar

p. 48, 49 (*left*): Williams College Archives

p. 49 (*right*), 55 (*bottom*): Michael Agee

p. 53: Walker Downey

p. 54 (*left*): Michele Slowey-Ogert

p. 54 (*right*): A. Blake Gardner

p. 55 (*top*), 129: Art Evans

p. 83: ©2014 Estate of Pablo Picasso/Artists Rights Society (ARS), New York

p. 88, 92, 93, 95 (*left*): Research and Academic Program staff, Clark Art Institute

p. 90: Scott Barrow Photography

p. 91: Mark McCarty

p. 94: Julie Walsh

p. 95 (*right*): ©fondation Hartung-Bergman

p. 121: ©2014 Artists Rights Society (ARS), New York/ADAGP, Paris

p. 124: ©2014 The Munch Museum/The Munch-Ellingsen Group/Artists Rights Society (ARS) NY

p. 125: ©2014 Artists Rights Society (ARS), New York/VG Bild-Kunst, Bonn

p. 126: Betty Sartori

p. 128, 130, 132, 133, 135: Clark Art Institute

p. 131 (*top and bottom*): ©Jeff Goldberg/Esto

p. 158: Photograph by Jacques Henri Lartigue ©Ministère de la Culture—France/AAJHL

p. 159: ©2014 Georgia O'Keeffe Museum/Artists Rights Society (ARS), New York

p. 162: ©Daniel Katz Gallery, London. Processing by Michael Agee

Back cover: Michael Agee

INDEX